THE GOLDEN AGE OF SAILING

Overleaf: Frank Beken at work in 1905 with the mouth-operated
marine camera he designed and which was key to his success

THE GOLDEN AGE OF SAILING

CLASSIC YACHT PHOTOGRAPHS

by

Beken of Cowes

TEXT BY WILLIAM COLLIER

TIMES BOOKS

RANDOM HOUSE

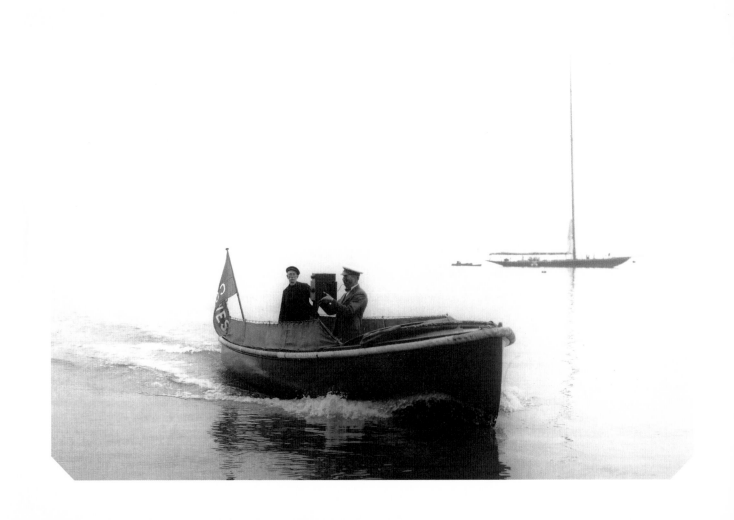

FOREWORD

THE PARTICULAR STYLE OF A BEKEN YACHT PORTRAIT SETS
the firm's work apart from that of any other photographers.
When Cowes chemist Alfred Beken first sought to experiment
with marine photography, the art was in its infancy. The first
photograph of a yacht underway had been taken off Cowes in
1881 but this and other early attempts were of inconsistent qual-
ity. From 1888 onwards, the Beken family successfully overcame
a myriad of technical problems to create a unique reputation for
quality that continues to flourish four generations later.

It was Alfred Beken's son, Frank, whose ingenuity, combined
with his father's early experiments, enabled him to perfect the
first great Beken images. To achieve outstanding results, he built
his own cameras which were specifically designed to stand up

to the rigours of use at sea. Following his subjects to sea in small launches, he used his body to counter balance the motion of the waves. Since he needed both hands to hold his camera, he fitted it with a pneumatic shutter release in the form of a rubber bulb that he could bite.

In the early days, Frank Beken rowed himself to the race courses. Estimating the courses of the yachts, the effect of wind and tide, he would wait for them to approach. Distances were not marked on his camera's view finder, instead there were settings for vessels of different sizes; from dinghies to liners. Standing, swaying in a small open boat, Frank Beken would monitor the approach of a thundering racing yacht until it three-quarter-filled his view finder and, with a bite, would

secure a unique image. Shots could not be wasted, the reloading time prevented second chances and the sheer weight of the glass plates prevented him from carrying more than thirty.

The advent of motor launches eased the workload but the technique remained the same. When Keith Beken joined the firm in the 1930s, he too built his own camera and continued to use glass plates long after others had discarded them. Similarly, the firm continued to make its own developers and fixers. The result is a remarkable consistency of technical quality in the 75,000 glass plates of the Beken archive. But, the Beken images reveal more than mere technical skill. They display a rare sensitivity to the subjects, exhibiting them at their best and capturing their power, romance, even playfulness.

Contents

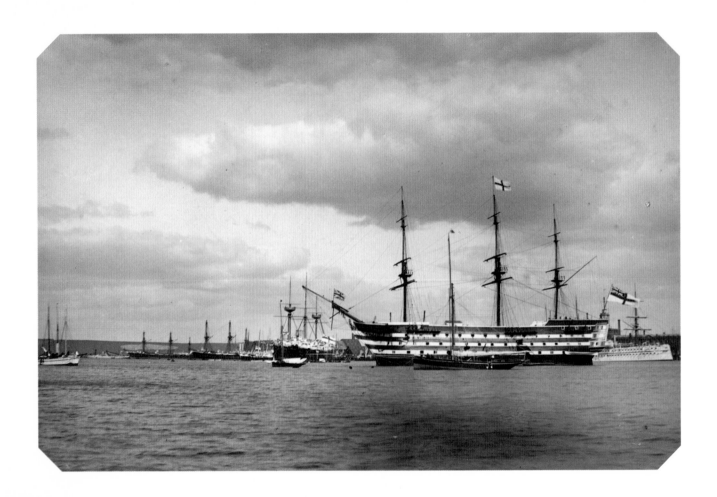

1880–1889

A NEW GENERATION

A NEW GENERATION

RECORDS OF BRITISH YACHTS AND YACHTSMEN EXIST AS far back as the seventeenth century but it was only with the end of the Napoleonic Wars that yachting began to be organised in a recognisable form. The formation of the Cowes-based Royal Yacht Squadron in 1815 made the Isle of Wight the centre from which naissant yachting spread around the world.

In 1851, the Royal Yacht Squadron sponsored a race round the Isle of Wight that was won by the New York Yacht Club schooner *America*. With this founding race of what became the America's Cup – the premier trophy in yachting – international rivalry was established.

Despite such competition and the tremendous growth of yachting through the mid-Victorian period, it was not until the

1880s that a series of developments fostered a period of rapid expasion that continued until the Second World War.

America's example had led to the two-masted schooner becoming the type of yacht most yachtsmen favoured through the 1860s and 70s. These were relatively practical vessels offering comfortable accommodation and their owners could use them equally well to race off Cowes or to cruise further afield.

In the mid-1870s, the conservative parameters that limited yachts to being good all-rounders were smashed by the emergence of independent, scientifically trained yacht designers. Along with these came a new breed of yacht owner who accepted that winning races required a specific type of yacht that would no longer be suitable for long-distance cruising. Once this

fundamental divide between cruising and racing yachtsmen was established, yacht types were further fragmented. The increasing adoption of steam power, at first combined with sail and later as the sole means of propulsion, gave rise to ever larger floating palaces. At the other end of the spectrum, more and more yachtsmen began to take an active part in the management of their yachts and opted for smaller yachts requiring few or no professional crew. These "Corinthian" yachtsmen not only made remarkable voyages but experimented widely, introducing yet further developments in yacht design.

In 1875 the leading racing yachtsmen formed the Yacht Racing Association which, from 1881, dictated the rating rules that governed the design of racing yachts. The new generation of yacht

designers and their patrons aimed not only to maximise speed within the restrictions that governed the various classes, but also to find loop holes in the rules. The discovery of these and the search for improvements prompted a series of new rating rules as the amateurs of the Yacht Racing Association endlessly sought to promote and re-establish racing on an even footing.

Based in Cowes, the epicentre of yachting, but with the naval and commercial ports of Portsmouth and Southampton within easy reach, Frank Beken developed his own camera in the 1880s and recorded the tremendous variety of maritime subjects. Whilst the wealthy patrons of yachting made their vessels a rewarding subject, the Beken archive extended further, covering the full range of marine and local subjects.

Amphitrite, 1889

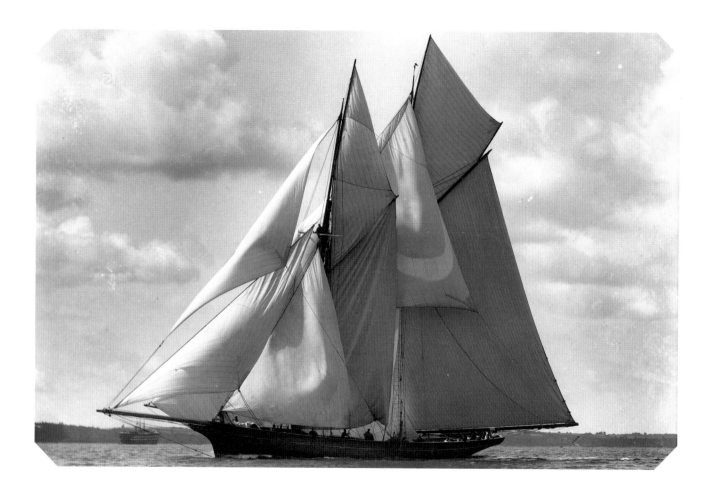

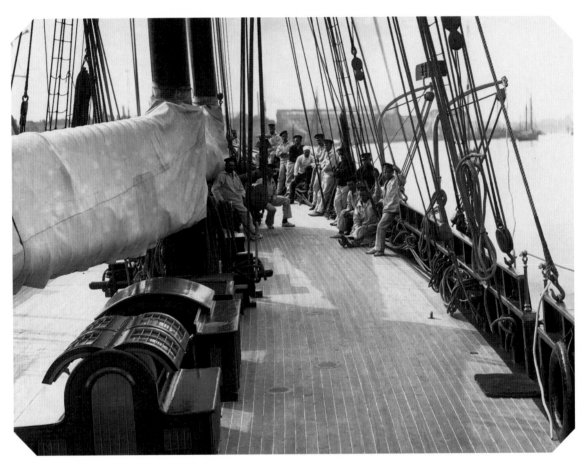

Livonia deck, 1897

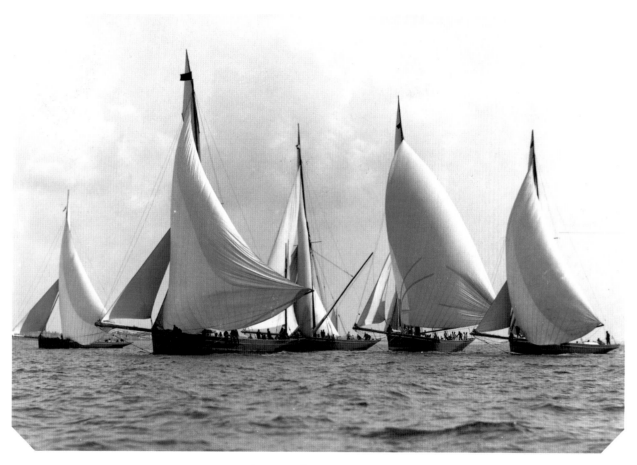

Straight sterns, 1887

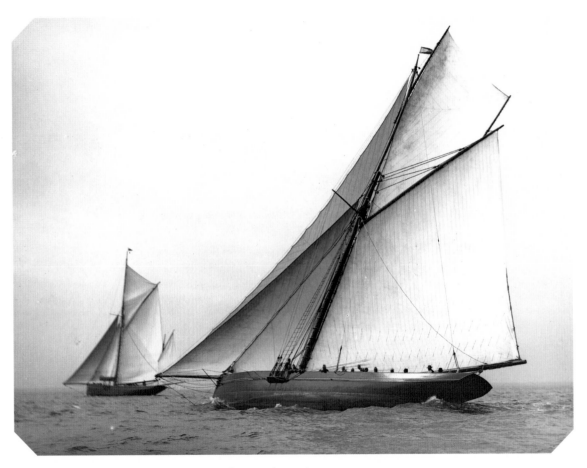

Sleuth Hound, 1886

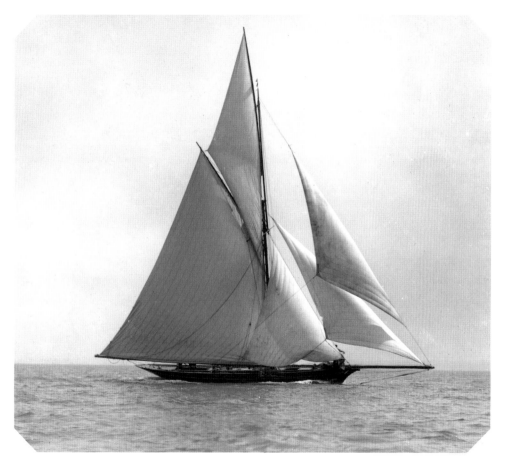

Buttercup, 1882

Thistle, 1887

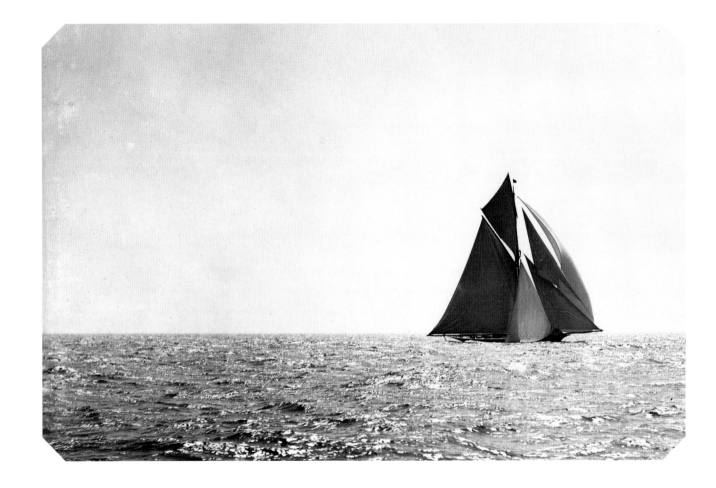

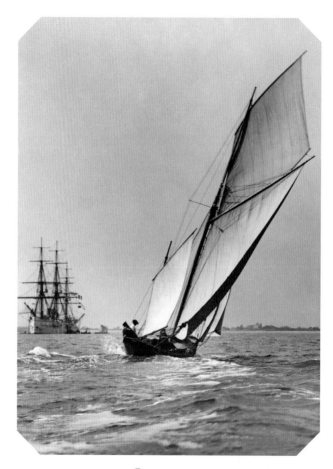

Cowes, 1885

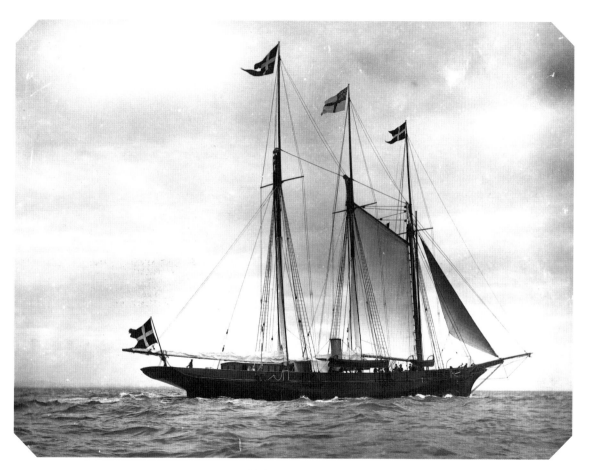

Chazalie, 1885

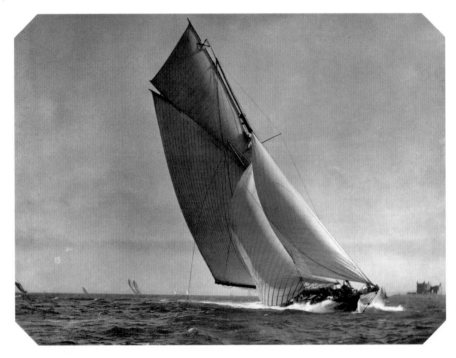

Mohawk, 1888

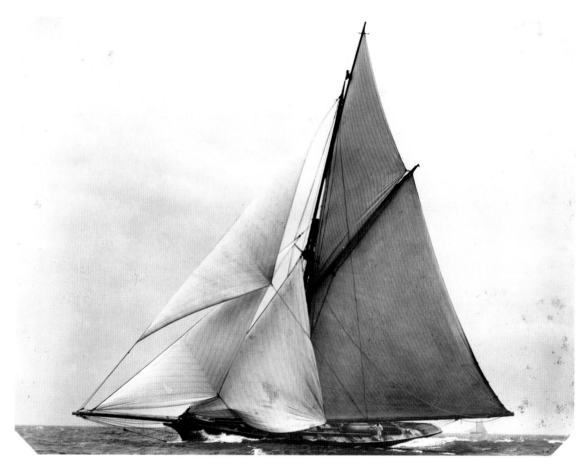

Petronella, 1888

Heathen Chinee, 1889

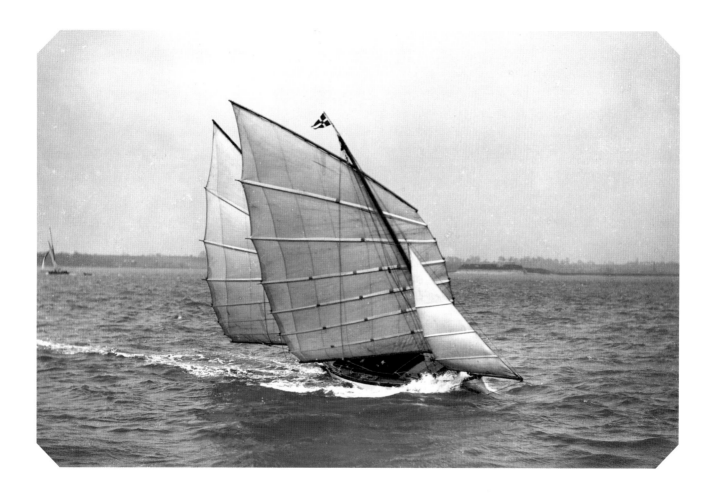

Towing out, 1888

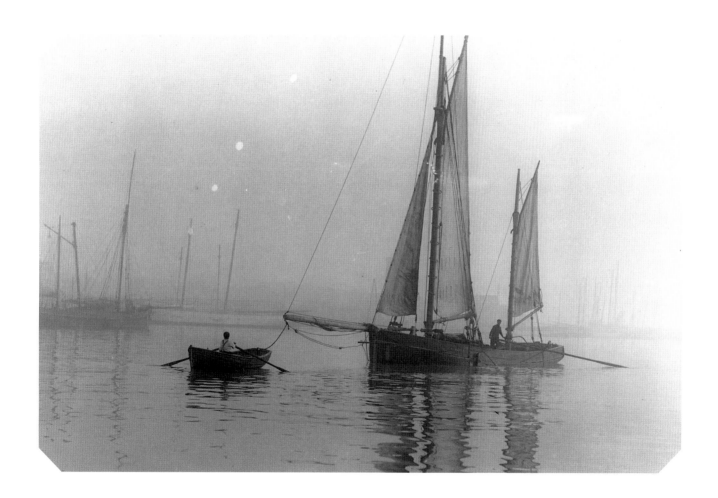

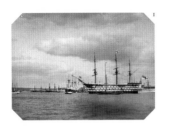

1

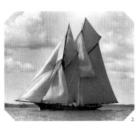

2

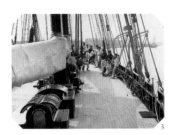

3

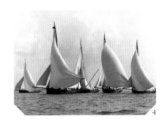

4

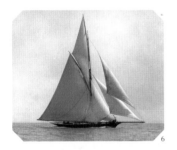

5

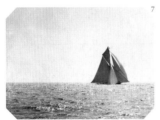

6

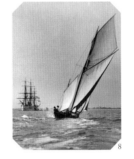

7

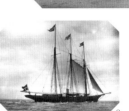

8

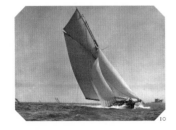

9

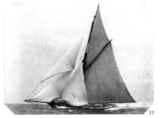

10

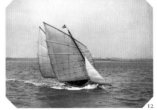

11

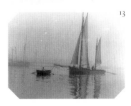

12

13

1 Nelson's legacy inspired generations of amateur sailors. His flagship, the HMS *Victory* is seen here in Portsmouth Harbour in 1882.

2 The schooner *Amphitrite* is typical of the type that was used for both racing and cruising throughout the 1860s and 70s. Although not launched until 1887 she was already an anachronism at a time when racing was dominated by various single-masted cutter classes.

3 In 1871 *Livonia* was beaten in the second challenge for the America's Cup. It was the last time the British entered a schooner to compete in this contest.

4 The straight-stemmed racing cutters of the 40-ton class at close quarters. Known as the "fighting forties", they were the most active racing class of the early 1880s.

5 The Marquis of Ailsa's *Sleuth Hound* was one of three new 40-ton cutters launched in 1881. Designed and built by William Fife of the Scottish yacht building dynasty, she was only moderately successful.

6 The 10-ton cutter *Buttercup* was the sensation of the 1881 season. Designed, built and sailed by her amateur owner, she was the first racing cutter to have a fiddle bow when the straight stem was *de rigueur*. By dominating her class she set a new trend.

7 A new rating rule in 1887 enabled the Glasgow-based designer George L. Watson to design this stunning challenger for the America's Cup. Although that trophy was to remain secure in American ownership until the 1980s *Thistle* briefly showed the way ahead.

8 This gaff-rigged yawl seen off Cowes in 1885, with square rigger *Stosch* in the background, exemplifies the pleasures of small boat yachting, discovered by an ever growing number of hands-on Victorian yacht owners.

9 *Chazalie* was one of a small number of extremely large three-masted auxiliary schooners built in the 1870s. These marked a developmental stage in yachting when designers sought to incorporate the advantages of steam power in an existent type of sailing vessel. They were soon superseded by the steam yacht.

10 Under the 1887 rating rule changes, the 40-ton class was superseded by the 40-raters and in 1888 *Mohawk*, designed by C. P. Clayton, set the tone in the new class.

11 The largest racing class of the 1888 season were the new 60-raters, amongst which *Petronella*. Designed for the Earl of Dunraven by Alex Richardson, she was consistently defeated by her counterpart, designed by George L. Watson, causing the earl to shift allegiance when he replaced her before the end of the season.

12 The junk-rigged yawl *Heathen Chinee* exhibits the full inventiveness of amateur designers. When first launched in 1889 she stunned contemporary critics by proving to be remarkably fast.

13 Flat calm on the Medina river. In the days before small auxiliary engines, oars often provided the only means of making any progress. Here the mate and skipper of a small fishing boat are both rowing from their respective positions.

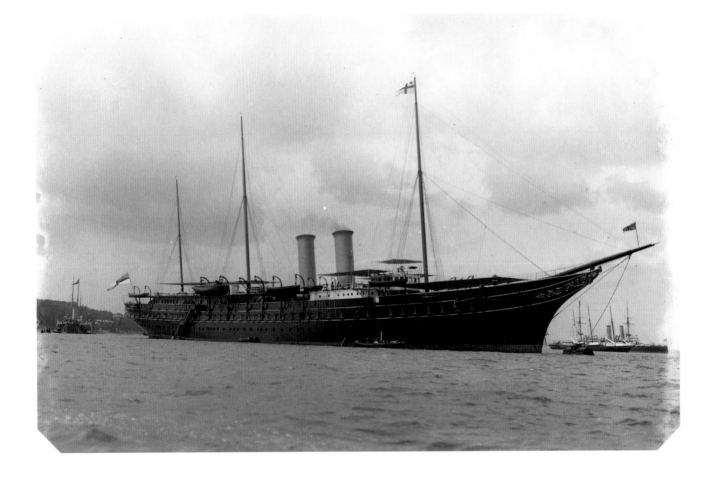

1890–1899

TRIUMPH AND FALL

TRIUMPH AND FALL

THE EARLY 1890s SHOWED NONE OF THE PROMISE OF WHAT
was to come. In the larger racing classes, few yachtsmen were
building new yachts and the existent yachts had been built to
a variety of rating rules making competition between them
unsatisfactory. As would happen time and again, the rule-
makers overestimated the willingness of yacht owners to build
to the endless procession of new rating formulas they devised.

The sport's difficulties were resolved on the one hand through
royal patronage, and on the other by yacht owners who simply
chose to build smaller yachts which they could afford to replace
more often. The overall effect was a relative democratisation
of the sport. With races for smaller yachts and the participa-
tion of royalty, the popularity of yachting increased.

From its earliest years, the Royal Yacht Squadron had enjoyed close links with the royal family and these were considerably reinforced throughout Queen Victoria's reign. With the royal family in residence at Osborne House and the cream of British aristocracy at the Royal Yacht Squadron, the social dimension of yachting grew. Equally, and in large part due to Queen Victoria's European relations, the annual Cowes Week regatta was increasingly frequented by the royal and imperial families of Russia, Austria, Germany and Spain.

To come to Cowes these crowned heads emulated Queen Victoria and acquired state yachts. When the Russian Tsar out-built all his contemporaries, Queen Victoria retorted by commissioning a third *Victoria & Albert*. Thus in 1889 Britain's

symbolic superiority was re-established with a 430-footer that no other state was quite able to match. When it came to racing, rivalry was equally acute: the Prince of Wales (later Edward VII) and the German Emperor Wilhelm II took the lead. They were later joined by the younger King Alphonso XIII of Spain.

Spurred on by the Emperor's acquisition of *Thistle* in 1892, the Prince of Wales commissioned *Britannia*, a new first class racing yacht, for the 1893 season and this in turn provided the impetus for an unparalleled spate of yacht building. The Earl of Dunraven challenged for the America's Cup in both 1893 and 1895 and the scale of developments in Britain helped lure the top American yachts across the Atlantic. After three halcyon years, the Yacht Racing Association introduced a new racing

rule rendering all existing yachts obsolete. Emperor Wilhelm II immediately built a new yacht to compete under it, but the Prince of Wales, no longer in with a fighting chance, gave up. Large yacht racing took a decade to recover.

Such erratic action by the sport's governing body further reinforced the appeal of smaller yachts and prompted the emergence of one-design classes. These classes, usually promoted by individual yacht clubs, simply stipulated that all vessels should be identical and were thus safeguarded from the possibility of yet further rule changes or technological breakthrough. In the wake of such changes, cruising yachtsmen increasingly declared themselves free of the strictures of Cowes yachting, thus largely avoiding the attentions of the Frank Beken lens.

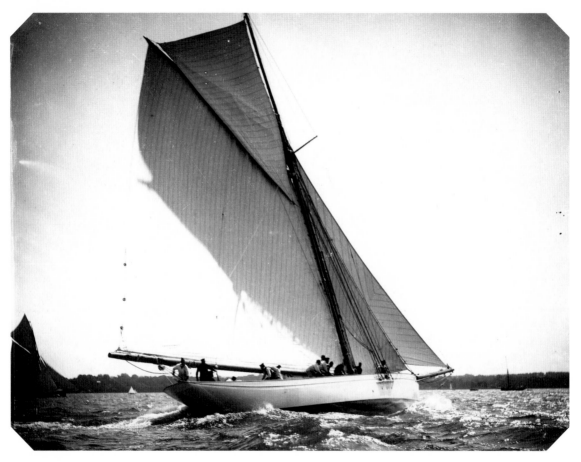

L'Espérance, 1891

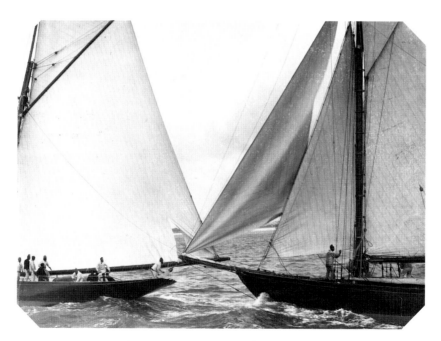

Varuna fouling Thalia, 1892

Iverna & Meteor, 1892

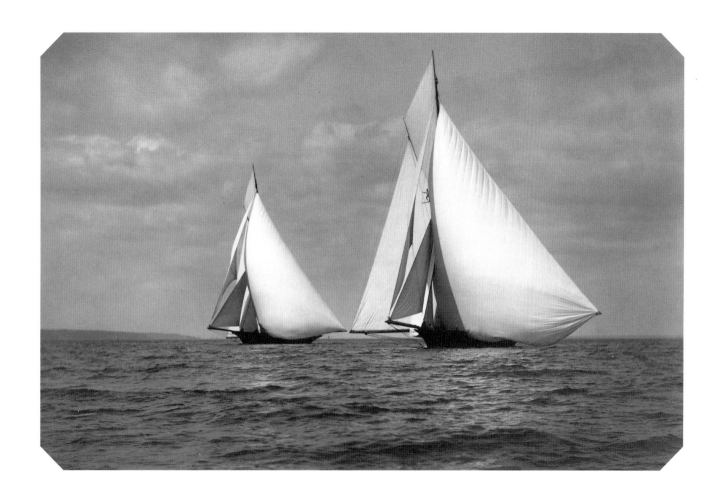

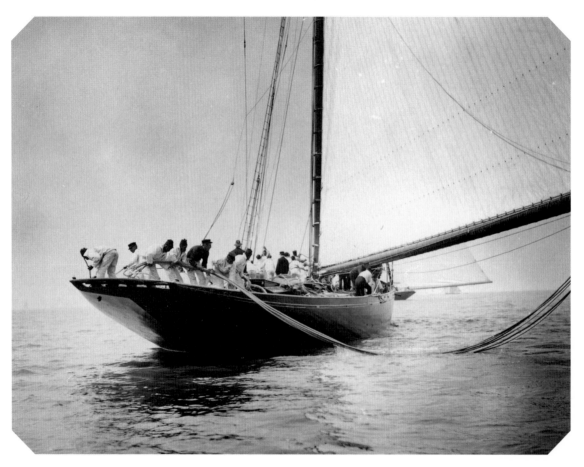

Britannia, 1897

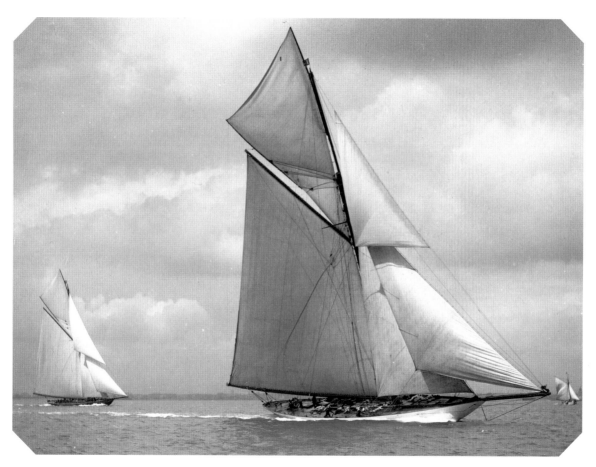

Vigilant, 1894

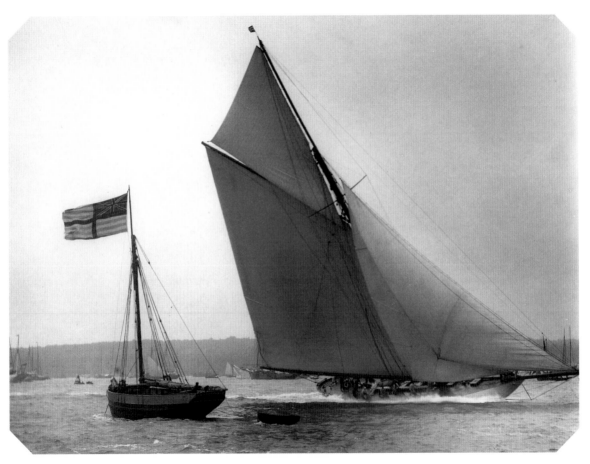

Vigilant, 1894

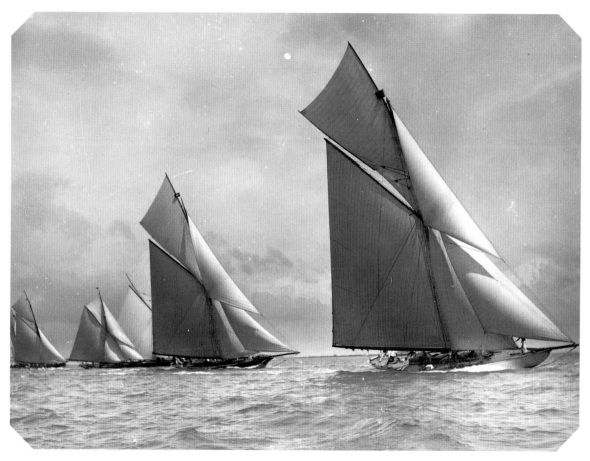

Caress leading Marion Creole, 1895

White Rose & Whisper, 1895

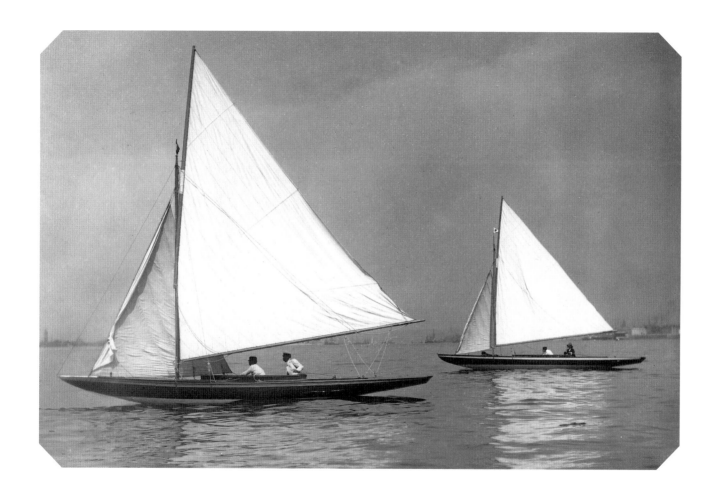

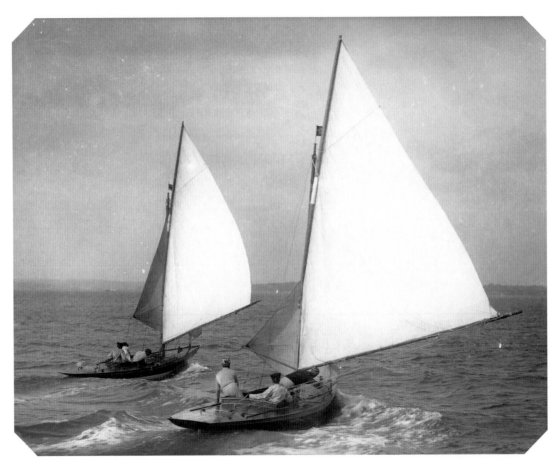

White Rose & Red Rover, 1895

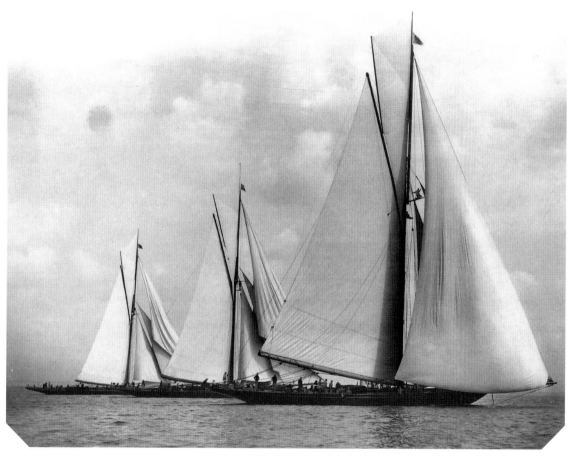

Big class yachts off Ryde, 1896

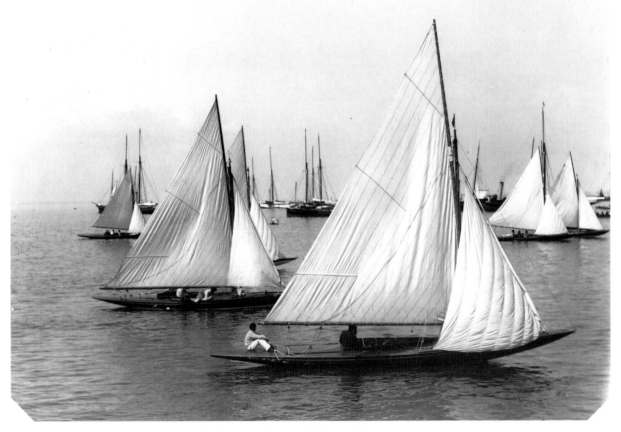

One-raters, 1896

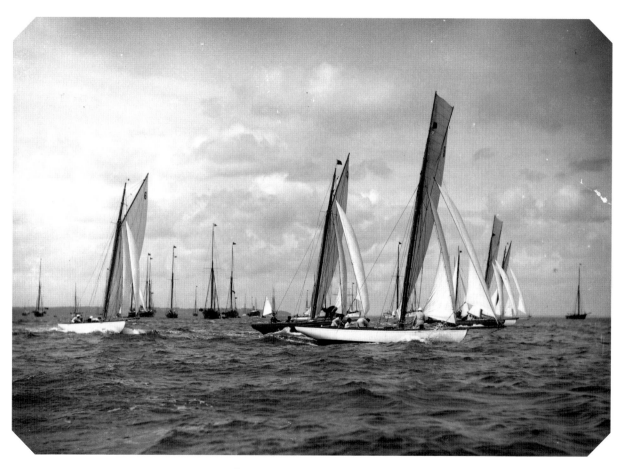

One-design class, 1897

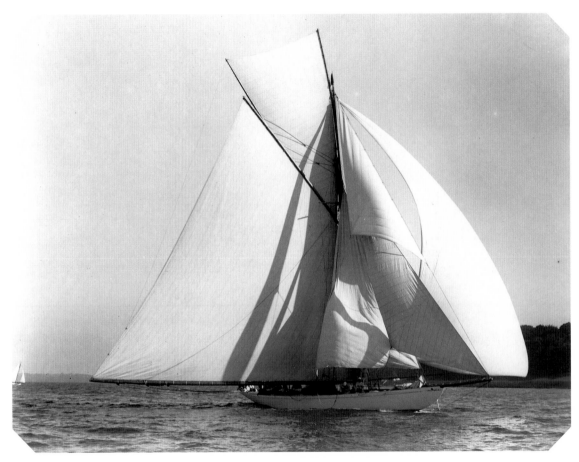

Morning Star, 1899

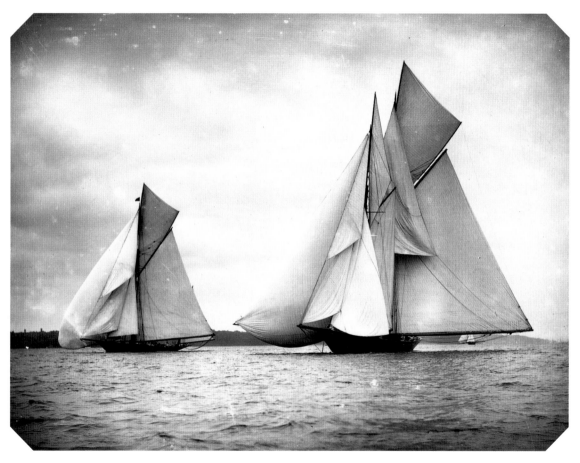

Satanita & Rainbow, 1898

The Medina, 1890

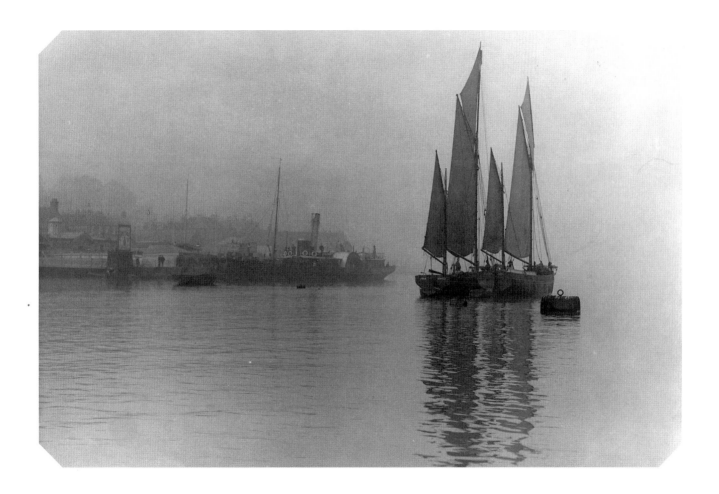

1

2

3

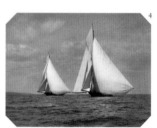

4

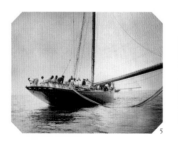

5

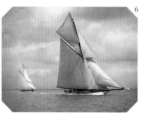

6

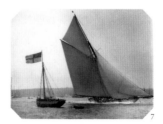

7

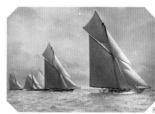

8

1 The third *Victoria & Albert* was the sixth of Queen Victoria's steam yachts. The Queen herself disliked it and retained its predecessor leaving the Prince of Wales to enjoy the largest state yacht ever built.

2 Alongside his out and out racing yachts, the Earl of Dunraven commissioned fast cruisers such as *L'Espérance* of 1891. The sheer number of yachts he owned ensured he always found a competitor of sorts.

3 Competition between rival designers William Fife and George L. Watson was intense and the racing close. Minor accidents such as this 1892 lapse of judgement by the new Watson-designed *Varuna* against the Fife-designed champion 40-rater *Thalia* were not uncommon.

4 1892 was the last season of the fiddle-bowed big class. Here the former *Thistle*, re-christened *Meteor* by Wilhelm II, ghosts down wind alongside *Iverna*.

5 In 1893, the Prince of Wales' *Britannia* began a 42-year racing career that remains unrivalled in the history of yachting. Her beauty and size never ceased to capture the imagination of all who set eyes on her.

6 After successfully defending the America's Cup in 1893, the American owned *Vigilant* took on the revitalised British big class in 1894. Here she is briefly ahead of *Britannia*, a position she was not able to maintain.

7 The presence of the American big class cutter *Vigilant* in British water during the 1894 season added international competition to an already vibrant class.

8 This 1895 image epitomises the problems of the too frequent rule changes. Both leading yachts were designed by George L. Watson but the new *Caress* is easily out-sailing the five year old *Creole* built to a previous rating rule.

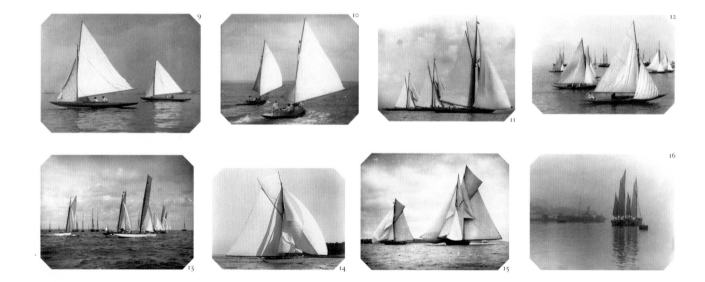

9 The one-raters *White Rose* and *Whisper* were just two of a class that was to become one of the most popular and developmental ever in British yacht racing. Constant experimentation led owners to replace their yachts with alarming frequency and, as with race horses, a proven winner could fetch many times her initial cost.

10 The one-rater *White Rose* has lost her lead to *Red Rover* in another image from 1895; the last year yachts were built to this class.

11 Three of the big class yachts off Ryde on 11 August 1896. Unable to accommodate yachts built to new and old rules the class broke up at the end of this season.

12 The well supported small classes remained popular throughout the controversies that were to mar yacht racing at the turn of the century. Here, the already superseded one-rating class continue to race together in 1896.

13 The identical yachts of the many one-design classes that flourished in the late 1890s offered a safe haven from perpetual rule changes and technical developments.

14 *Morning Star* was designed to the standards of the 52-foot class of the Linear Rating Rule that was established in 1896. Although the new rule made plenty of provision for larger vessels, this was the largest class able to attract consistent support.

15 By 1898 yachtsmen were reverting to the all-round advantages of the large schooners. The great cutters built for the 1893 season that continued to race were optimised in the hope of surviving the inevitable mismatches that occurred. Here *Satanita*, converted to a yawl rig, is only just able to hold her own against the mighty schooner *Rainbow*.

16 The rise in the popularity of yachting provided summer jobs for many Cowes seafarers who still earned their livelihood under sail until the Second World War.

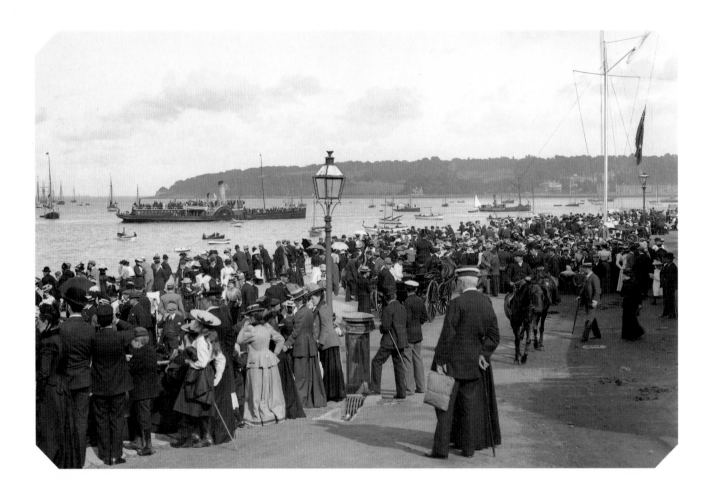

1900–1909

POPULAR SPLENDOUR

POPULAR SPLENDOUR

LARGELY OBLIVIOUS OF THE COMPLEX ISSUES THAT BOTH made and threatened to destroy the success of British yacht racing, the public took it up as a spectator sport. The relatively confined waters of the Solent provided a myriad of viewing points but for those able to get to Cowes there was the added bonus of a glimpse of the distinguished yacht owners.

Certainly the involvement of the Prince of Wales in the previous decade had greatly enhanced the popular appeal of yachting and this grew as Edward VII, now king, remained faithful to Cowes. With him, the King brought a new breed of yachtsmen eager to spend the surpluses of their recently acquired fortunes. The most prominent of the new yachtsmen was Sir Thomas Lipton, whose corner-shop success and

maverick advertising campaigns had made him a household name. The Earl of Dunraven's America's Cup challenges of the 1890s had descended into acrimony with each side casting aspersions on the other's understanding of fair play. On the King's advice Lipton challenged for the Cup in 1899. Failure brought renewed attempts in 1901, 1903, 1914 and 1930 and despite comments from the old guard that "the King had gone boating with his grocer" Lipton enjoyed tremendous popular support.

Although it was the pinnacle of the sport, America's Cup racing took place in relative isolation and had little effect on racing in home waters. On the Solent the big class had been killed off by the rule-makers and through the opening years of the twentieth century there was a gradual trickle-down effect.

With the exception of the medium sized 52-footers of the Linear Rating Rule, class racing was in a poor state.

None of the problems that plagued racing through the 1890s had been solved. New building techniques made it possible to reduce the weight of yachts' hulls and whilst this had clear implications for their racing potential, it also made them fragile. As a direct result, would-be yacht owners were faced with the prospect of not only building vessels that could be very quickly superseded but that would have no residual value since they were totally unsuited for conversion to cruising.

In an attempt to avoid this dire predicament, numerous yacht owners commissioned large schooners, to no particular class or rule. They raced together on a necessarily unsatisfactory

handicap basis but proved that there was no shortage of patrons willing to build large vessels if only the right rules could be established. In forming an international committee, the Yacht Racing Association surpassed itself with the introduction of the First International Rule, which was adopted throughout Europe in 1907. The new yacht rating formulae encouraged a type of yacht that owners would be willing to commission. It imposed restrictions on minimum weights and, more importantly, it vastly increased the scope for Europe-wide yacht racing since all would now be under the same rule. The rule's success was almost immediate and the large number of "metre classes" anticipated, as well as a new class of racing schooners, were widely adopted.

Cowes Regatta, 1900

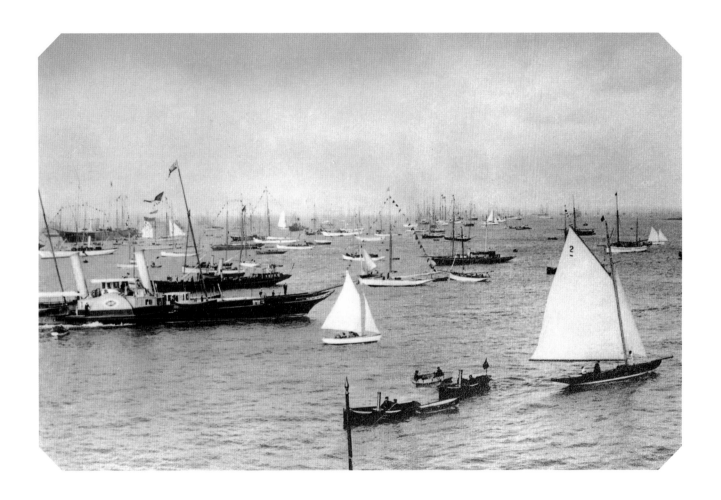

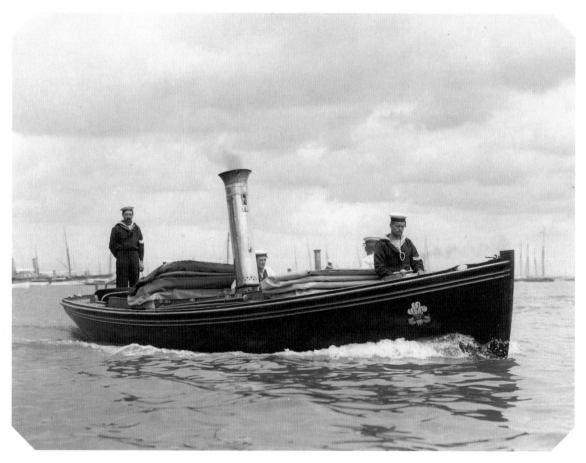

Royal Launch, 1901

Shamrock II, 1901

Ryde Town Cup, 1903

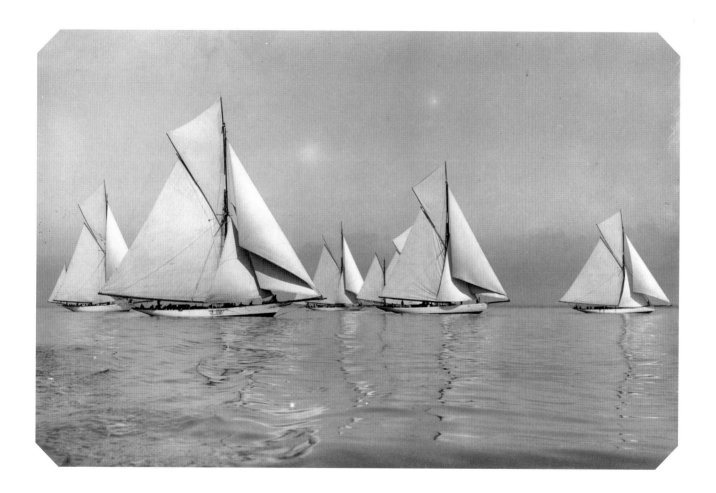

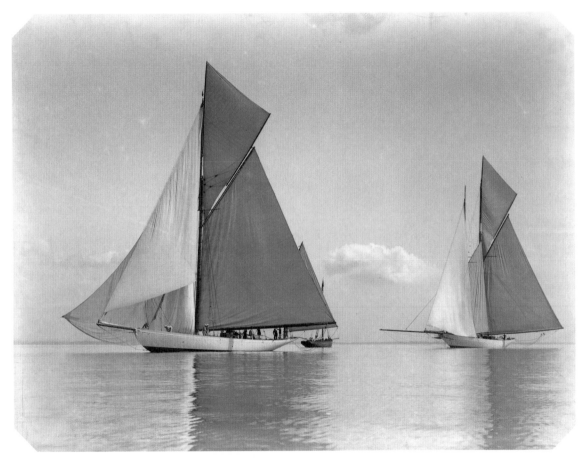

Valdora & Cicely, 1904

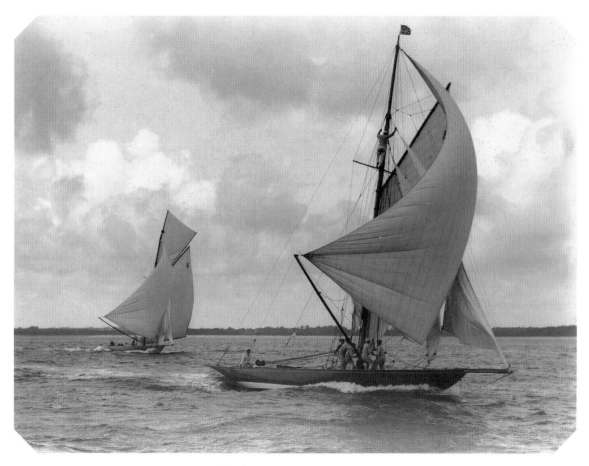

South Coast one-designs, 1904

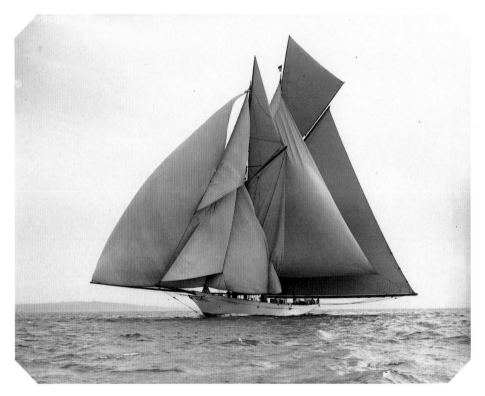

Clara, 1906

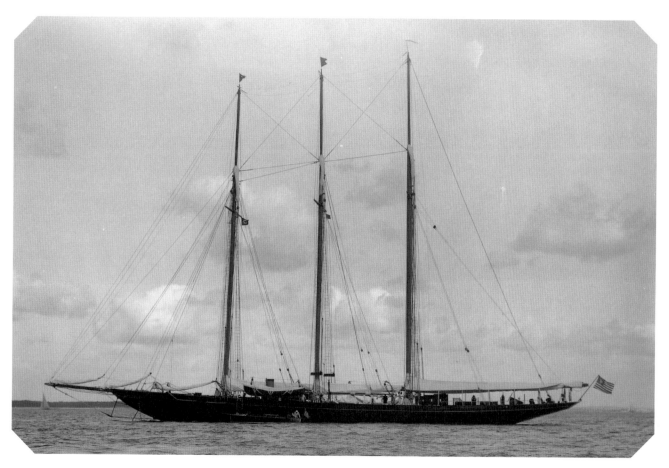

Atlantic, 1905

Sonya, Moyana & Britomast, 1905

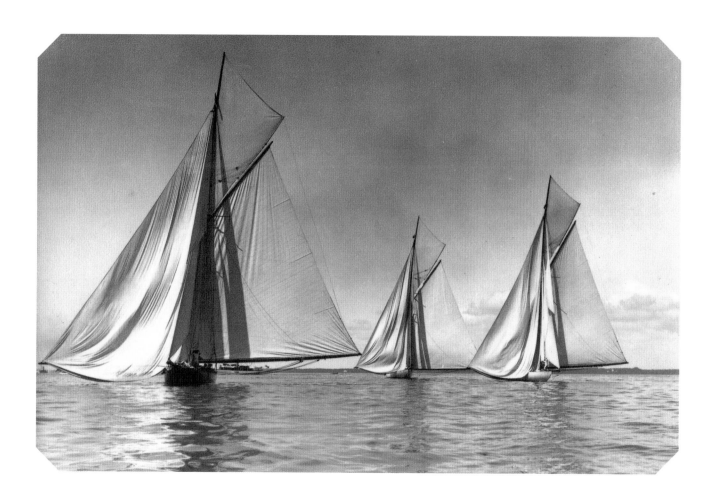

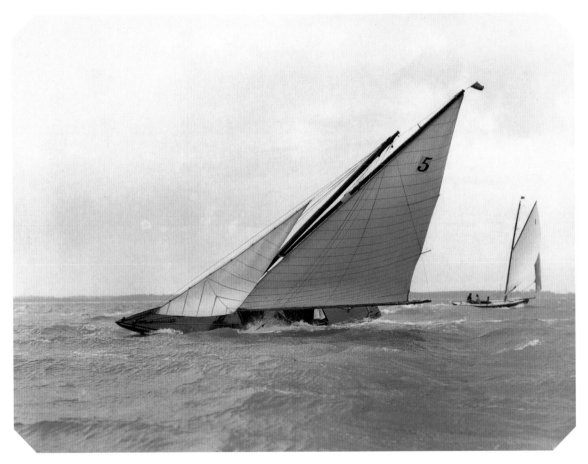

Anitra, 1906

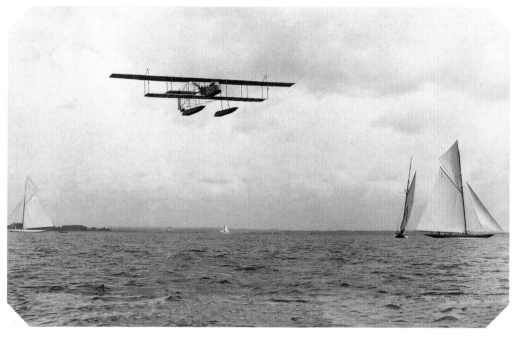

Graham White flying at Cowes Regatta, 1908

Adela leading the Brassey Cup, 1908

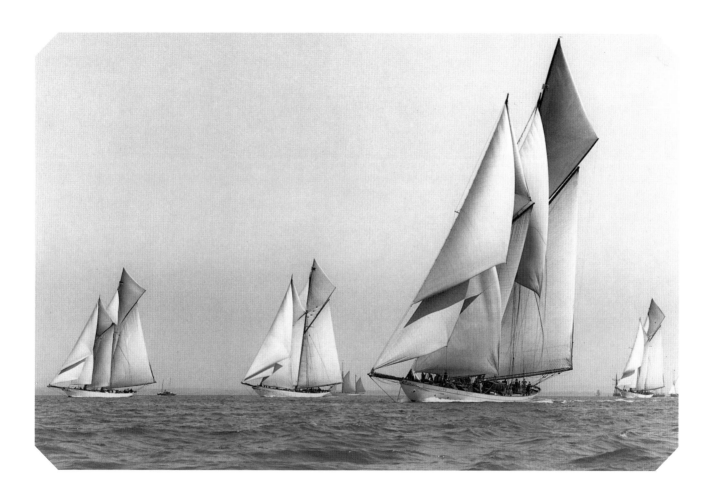

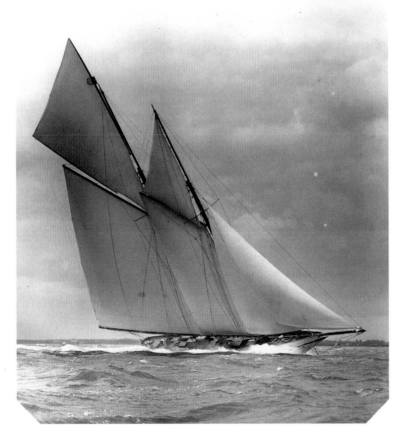

Cicely, 1908

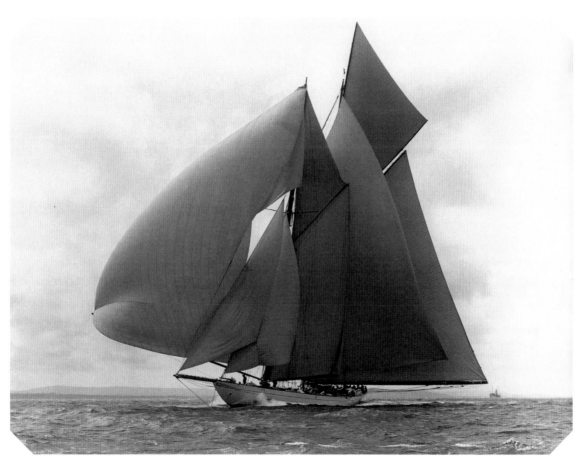

Germania, 1908

Marvin's Yard, 1907

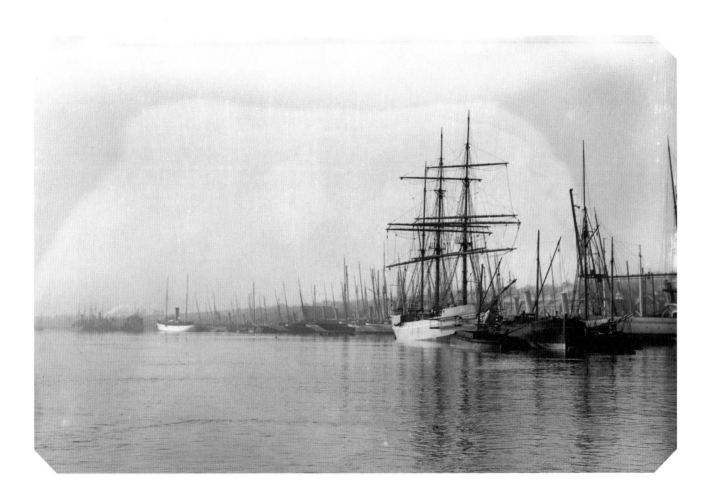

1

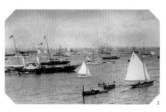

2

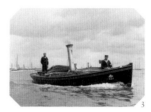

3

4

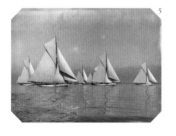

5

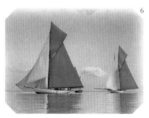

6

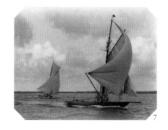

7

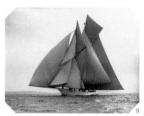

8

1 The presence of numerous crowned heads of Europe alongside many of the world's finest yachts drew large crowds of spectators to the annual Cowes Week.

2 Together with the larger state yachts, the British royal family also had tenders to ferry them to and from Cowes. Here the royal tender *Alberta* is making her way through the anchored fleet during the Cowes Week of 1900.

3 The royal fleet included several steam pinnaces which were carried on the royal yachts and used for going ashore or calling on other yachts.

4 In 1901, Sir Thomas Lipton's second America's Cup challenger *Shamrock II* was accidentally dismasted during sail trials. There were no injuries and a new rig was quickly built but the presence of King Edward VII on board caused some comments as to the inadvisability of "going boating with one's grocer".

5 With Cowes positively overflowing with yachts during the summer months, other Isle of Wight towns such as Ryde sought to attract the glamorous visitors by putting up racing trophies. This is the start of the race for the 1903 Ryde Town Cup.

6 Following the demise of big class racing, an ill-assorted fleet of larger yachts raced in an unsatisfactory handicap class that could do very little to remedy the fundamental disparities between very different vessels. In light airs the large schooner *Cicely* would have virtually no chance against the smaller yawl *Valdora*; given half a gale the outcome would be entirely different.

7 Throughout the problems in yacht rating that characterised the early years of the century, classes of identical yachts, such as the South Coast one-designs, flourished.

8 The schooner *Clara* was built in Southampton for one of the German Emperor's many courtiers who took up yachting at his request. Not designed to any rating rule this was a comfortable cruising yacht and occasional participant in handicap racing.

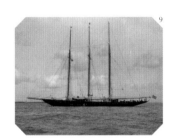

9

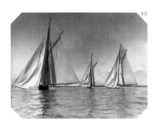

10

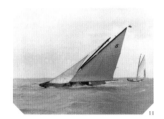

11

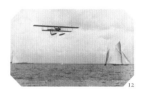

12

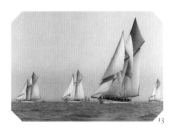

13

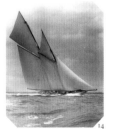

14

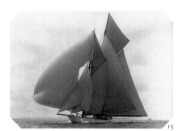

15

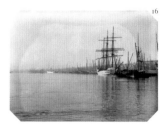

16

9 In 1905, Emperor Wilhelm II offered a substantial gold trophy for the winner of a transatlantic race. During the First World War the trophy was melted down and found to be only gold-plated lead. The American schooner *Atlantic* won the deceptive trophy and established an enduring record.

10 The 52-footers of the Linear Rating Rule were the largest racing class that mustered consistent support. Joining the class in 1905, Mrs Turner-Farley considered that British designers had introduced just about every refinement they could think of and turned to the American designer Nat Herreshoff for the designs of her *Sonya*.

11 The William Fife-designed 32-foot linear rater *Anitra* was launched in 1906 and although a successful yacht she was superseded the following year when her class was abolished with the introduction of the International Rule and a series of new racing classes.

12 By 1908 the aeronautical prowess of pioneer Graham White was matched by the Yacht Racing Association whose International Rule led to the re-establishment of the big class to which Sir Thomas Lipton contributed the highly successful green-hulled *Shamrock*.

13 The owners of the large schooners were the slowest to adapt to the changing rating rules and continued to race their older yachts together long after they were deemed to have been superseded. At the start of the race for the Brassey Cup in 1908, the British-owned *Adela* is leading the Emperor's *Meteor III* and the Krupp-owned *Germania*.

14 *Cicely*, designed by William Fife, exhibiting the power of a large schooner with all upwind sails set. In a bid to beat the Emperor her British owner built two yet larger schooners and eventually retired triumphant at the end of the 1913 season.

15 Max Oertz was the only German designer who came close to matching the perfection achieved by British and American naval architects. *Germania* was built to race against the Emperor, Wilhelm II, and seen exhibiting her full wardrobe of downwind sails.

16 For most yacht owners yachting was strictly a summer hobby and every winter Marvin's Yard in Cowes became one of the largest laying up yards in the world.

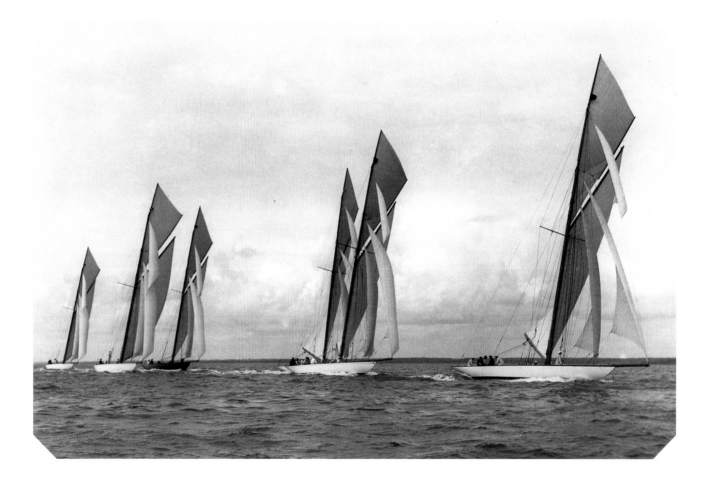

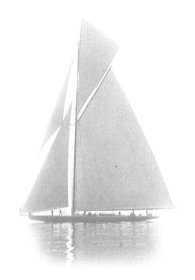

1910–1919

HALCYON YEARS

HALCYON YEARS

IN THE YEARS LEADING UP TO THE FIRST WORLD WAR, yacht racing enjoyed a previously unknown state of stability. This was entirely due to the benefits of the new International Rating Rule established in 1907.

Without undermining the prestige of Cowes Week, a European circuit was established; the Emperor Wilhelm II organised Kiel Week in its image and King Alfonso XIII initiated annual regattas in Santander. This led to parallel, and equally successful, developments in France and the Scandinavian countries.

These European initiatives were scrutinised by American yachtsmen. They had not suffered the same stream of reverses as their European counterparts but neither had they managed to nurture such active, compatible and broadly based sport.

If the rule-makers had made one mistake, it was to have provided too many classes. But by 1910, yachtsmen had ironed out this problem by agreeing to build to whichever class was best supported in their local waters. In the Solent, the 8-metre became the local class and, of the bigger classes that travelled from regatta to regatta, the 15-metre class emerged dominant. These yachts, of very similar sizes to the former 52-foot Linear Raters, simply took off where the old class left off. The Spanish king built to the class and it also found supporters in France and Germany. Indeed its very success contributed to the relative failure of the larger classes to find widespread support.

In the first year of the new rule, two owners had built to its largest cutter class, the 23-metre class, and in 1908 Sir Thomas

Lipton joined them but the accidental sinking of one yacht and the sheer quality of the sport enjoyed in the 15-metre class deterred other yachtsmen from joining in.

In the last two seasons leading up to the war, one British yachtsman finally took up the Emperor's challenge and built to the new schooner class. As a result, the Emperor was beaten in 1913 which prompted him to order his fourth and last *Meteor*. Amidst the British euphoria Sir Thomas Lipton renewed his quest for the America's Cup and commissioned a new challenger, *Shamrock IV*. Since *Shamrock IV* was built to American rules she was not subject to the minimum weight restrictions that existed in Europe and her designer Charles E. Nicholson took full advantage. It was his brain child that had beaten the Emperor and from 1912

onwards his 15-metres had been unbeatable. At last there seemed
to be a real possibility of winning back the coveted trophy.

War broke out just before the starting gun of 1914 Cowes Week
was fired. The German yachts already present were summarily
arrested and German trophies won by British yachtsmen were
quickly returned. *Shamrock IV* was off Bermuda and reached
New York only to be laid up till 1920. When the long awaited
contest finally took place, she was the most successful yet of
all the British challengers, but still not quite good enough. The
shock of her lightweight construction and the example set by
European yacht racing eventually led American yachtsmen to
harmonise their rating rules with the British and thus prompt
some of the greatest ever international yacht racing.

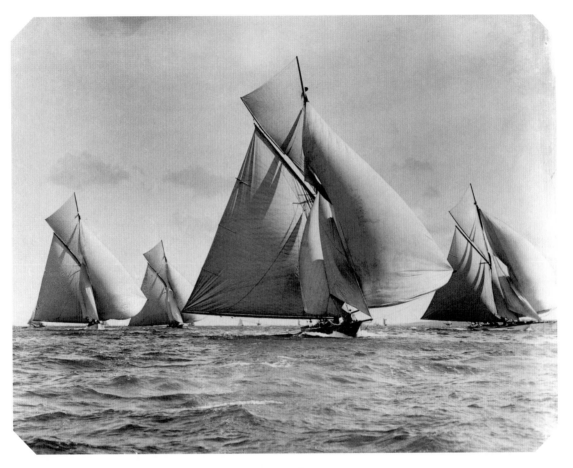

15-metre class, 1911

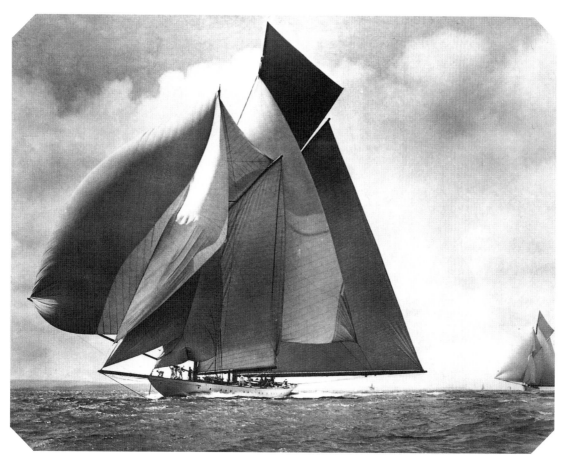

Westward, 1911

Meteor leading Waterwitch & Germania, 1911

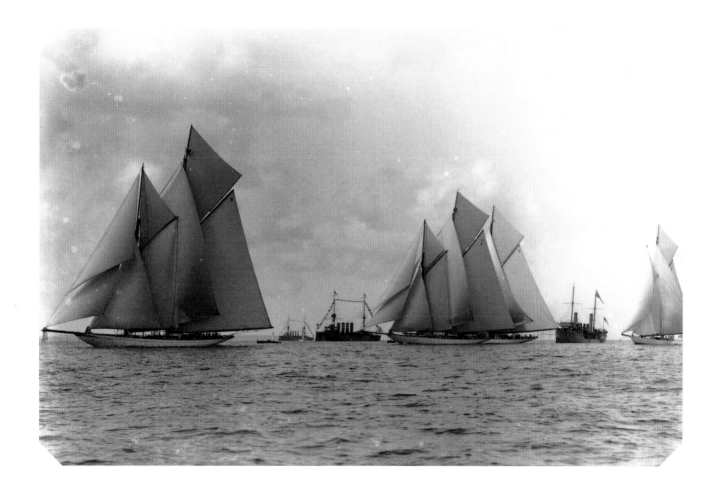

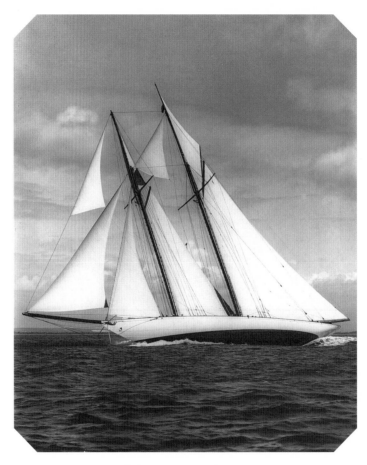

Watermitch, 1911

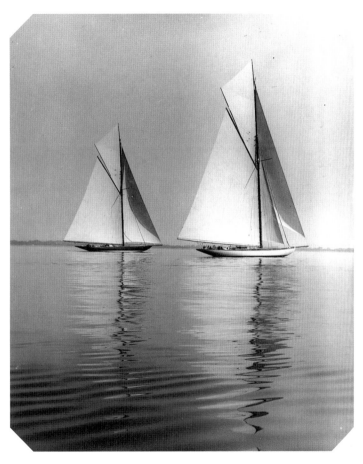

Shamrock & White Heather II

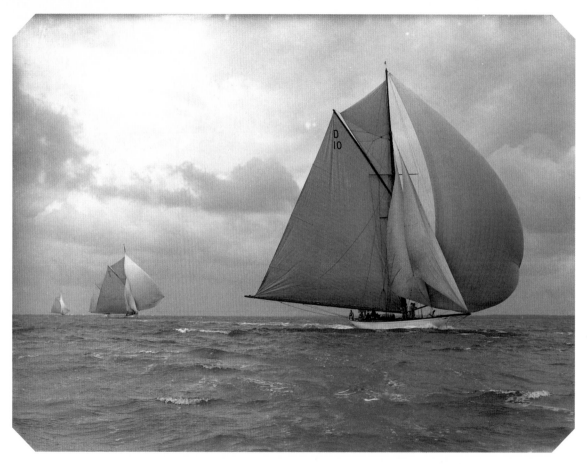

The Lady Anne, 1912

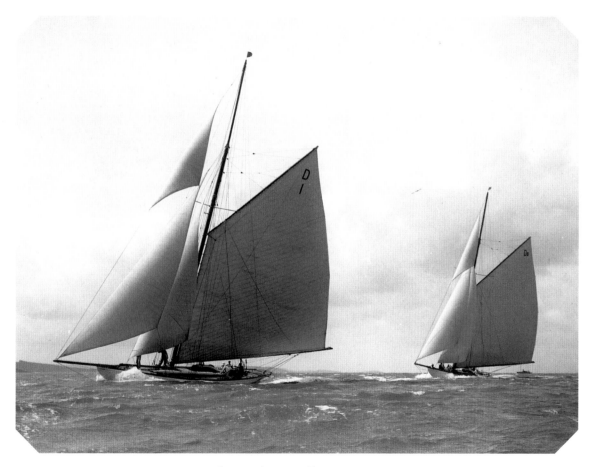

Mariska & Paula II, 1912

Newport Quay, 1911

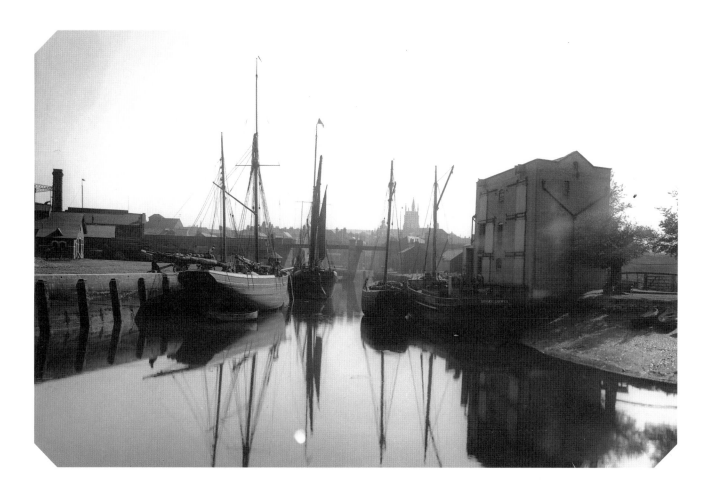

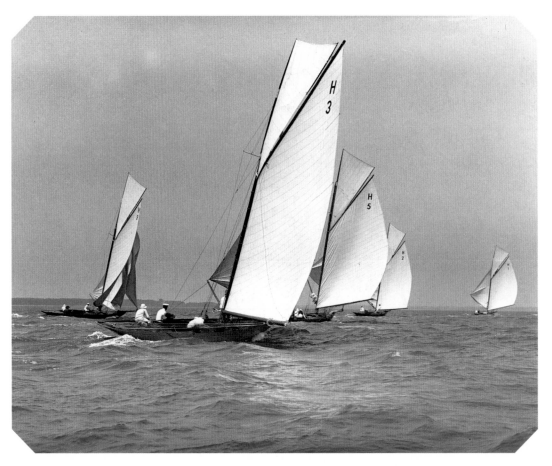

8-metre class, 1912

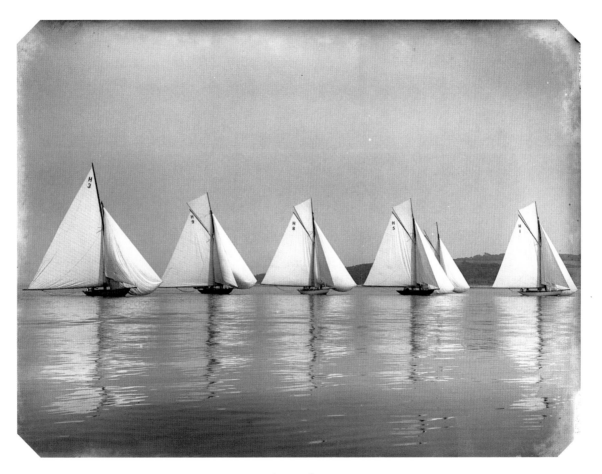

8-metre class, 1911

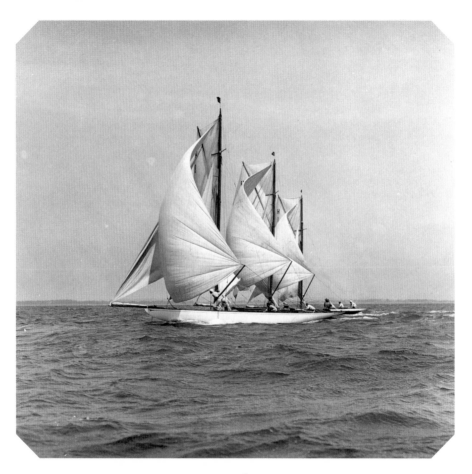

8-metre class, 1911

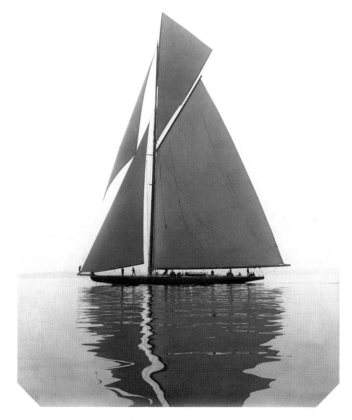

Shamrock IV, 1914

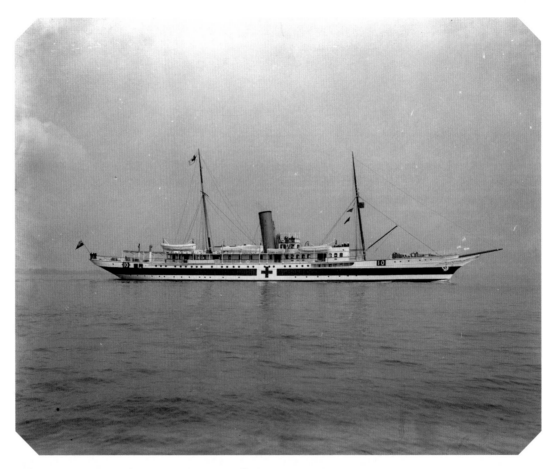

Liberty, 1914

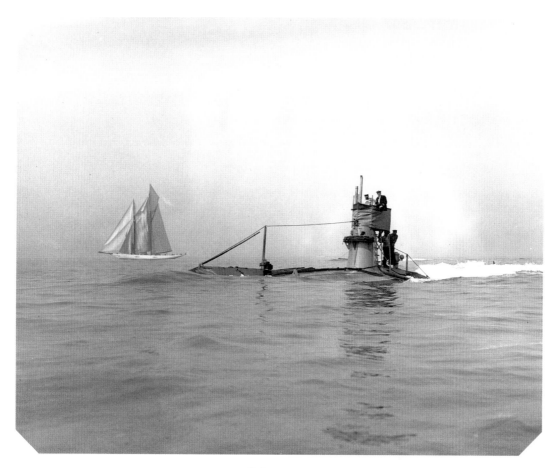

War, 1914

1

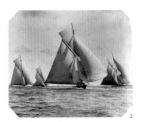

2

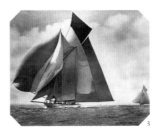

3

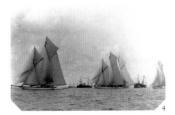

4

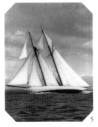

5

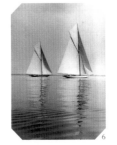

6

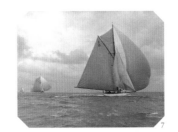

7

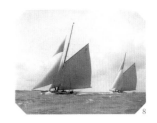

8

1 The great success of the International Rule was that it succeeded in establishing closely matched racing in a variety of long-lived classes. The 12-metre class was first adopted in Scotland but the Scottish yachts travelled south for Cowes Week. Here *Javotte* leads *Cintra*, *Cyra*, *Alachie*, *Nargie* and *Hera*.

2 The 15-metre class was the most successful of all the metre classes and saw some of the greatest yacht racing that ever took place in Europe. Nineteen yachts were eventually built to the class.

3 At the apex of yachting, the schooner class of the International Rule included the largest yachts ever built for inshore racing. Built in America, *Westward* was designed to race in Europe and throughout her long career was one of the great sights to be seen on the Solent.

4 The presence of Wilhelm II in the schooner class made victory a matter of national prestige and only a small number of yachtsmen could afford the financial and diplomatic cost of challenging. Here the Emperor's *Meteor* leads *Waterwitch* and *Germania*.

5 Having disposed of *Cicely* to build *Waterwitch* only to find he still could not beat the Emperor, Cecil Whitaker scrapped her. Her successor succeeded where *Waterwitch* failed and having made his point Whitaker gave up yachting.

6 Whilst many thought them the most beautiful cutters ever built, the 23-metre class was never popular enough to constitute an active big class. The green *Shamrock* and *White Heather II* were both designed by William Fife and enjoyed some very close racing.

7 When the 15-metre class lost their top racing trophy to a German yacht in 1911 the Scottish thread baron George Coats commissioned *The Lady Anne* to win it back. A rival British yacht beat Coats to it but *The Lady Anne* soon developed a reputation as a light-weather flyer.

8 Racing yachts such as the 15-metres *Mariska* and *Paula II* were not able to set all their sails in stronger winds. Remarkably these relatively extreme racing yachts regularly made long offshore passages to racing centres in Spain and Germany.

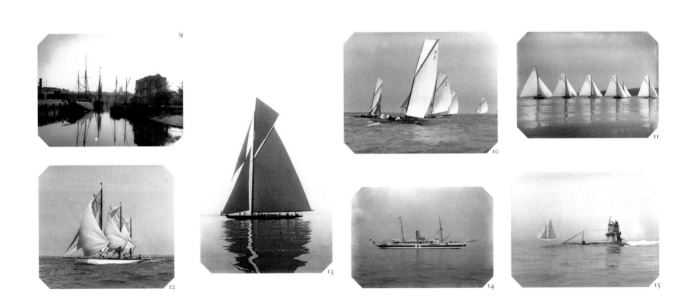

9

10

11

12

13

14

15

9 The sturdiness and short spars of these working vessels emphasise the extremes of the lofty rigs and fine lines that yacht designers adopted in the quest for speed.

10 The Solent 8-metre class running downwind in 1912. The popularity of this class led to it eclipsing the slightly smaller 6-metre class until after the First World War.

11 In the years leading up to the First World War experimentation in rig design was the main vehicle of progress in yacht design. The contrasting standing gunter rig of the vessel on the left contrasts with the more usual gaff rig of the other 8-metres.

12 The 8-metre class attracted a wide range of keen owners. Priests, soldiers and peers regularly raced side by side and even women owners were not altogether unknown.

13 Designed by Charles E. Nicholson, *Shamrock IV* had not quite reached New York, where she was to race for the America's Cup when war broke out. When the contest was eventually held in 1920 she proved to be the best yet of all the British challengers.

14 War brought an end to yachting. The majority of the British racing fleet was sold to the neutral Scandinavian countries, most of the large steam yachts were taken over by the Royal Navy but a few such as *Liberty* were converted to serve as hospital ships.

15 At the outbreak of war the British navy was ill-equipped to deal with the new submarine threat and the steam yachts of the Auxiliary Yacht Patrol formed the first line of defence.

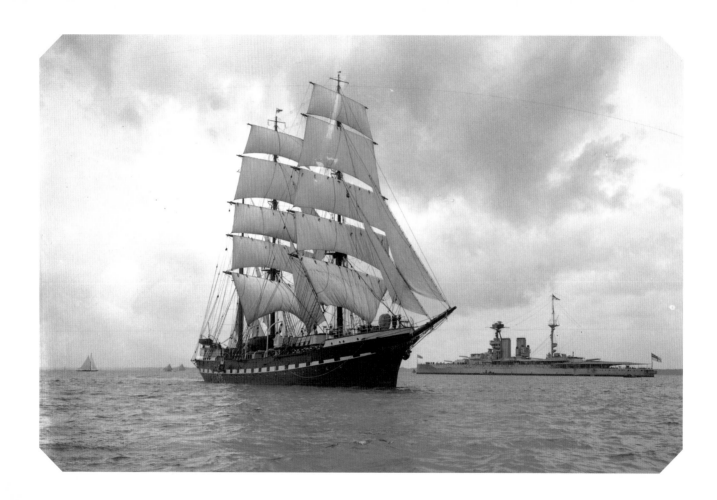

1920–1929

STARTING OVER

STARTING OVER

PEACE DID NOT IMPLY THE AUTOMATIC RE-ESTABLISHMENT of yachting. Crews, yacht owners and yachts had been decimated, wartime inflation made their costs seem prohibitive and raw materials were in short supply. Most of the large sailing yachts had had their lead keels requisitioned for more martial needs and the smaller yachts, including the entire 15-metre class, had been sold to the neutral Scandinavian countries. Most significantly, the International Rule had lapsed, removing the sport's very foundations.

Amongst the few yachtsmen who had the motivation and means to think of yachting in the immediate aftermath of war, some doubted that the Yacht Racing Association could repeat its success. Establishing the Boat Racing Association, they

sought a radical modernisation of the rating rules that would owe little to the pre-war racing yachts.

Given the tremendous political influence wielded by prominent yachtsmen, the sport received a substantial amount of government attention. In the aftermath of the war, the British government was concerned that any new British rating rule might not accord with Scandinavian desires, leaving these countries to become excessively influenced by Germany. George V, president of the Yacht Racing Association, corresponded with his Scandinavian counterparts and eventually the leading lights of the Yacht Racing Association were despatched to Denmark, Sweden and Norway on board a British naval destroyer. Given that the majority of Europe's pre-war racing yachts were then

in Scandinavian ownership, the new rule was to be designed to accommodate them. Despite foreboding and controversy at home, the Second International Rule of 1920, merely an up-dated version of the previous rule, established an excellent basis on which yacht racing might be resurrected. The Scandinavian countries adopted it and, to further underline their resolve, British yachtsmen elected not to compete against the Germans for ten years. In addition to European success, the new rule found favour with American yachtsmen and became the basis of new international competitions for the 6-metre class.

If international yacht racing could be reborn only in the smallest of yachts, there was no lack of grand aspirations for a renewed big class in home waters. George V took the lead

by fitting out the old *Britannia* and competing again in 1920. Against him, a motley fleet of mismatched yachts competed on an irredeemably flawed handicapping system. Despite the shortcomings the fleet grew. For some owners of relatively small yachts it was an undreamed-of opportunity to race against the King. Regardless of motivation, it provided the basis on which large yacht racing was gradually reestablished. Finally, in 1928 two new big class cutters were commissioned, a third following in 1929. Of the intermediate classes, the 15-metre class had been disbanded under the new rule and the 12-metre class took its place. As with its predecessors, the class was well supported and it became the mainstay of yacht racing, assuring continuity regardless of the fate of the more vulnerable big class.

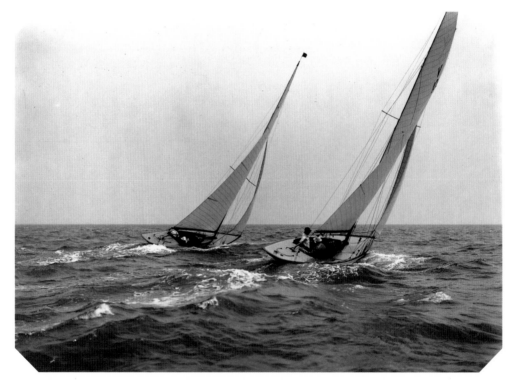

Sally & Joy, 1926

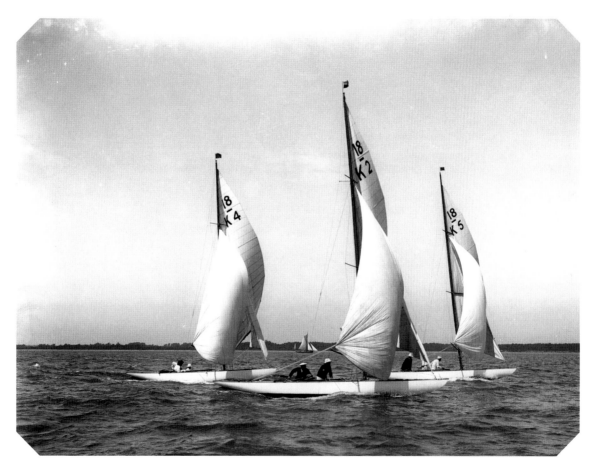

18-foot class, 1922

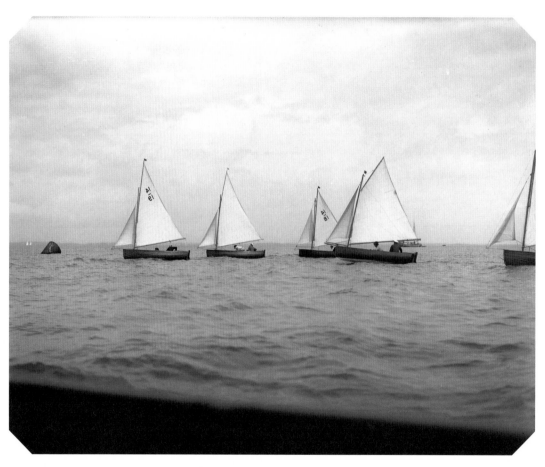

Dinghy racing, 1924

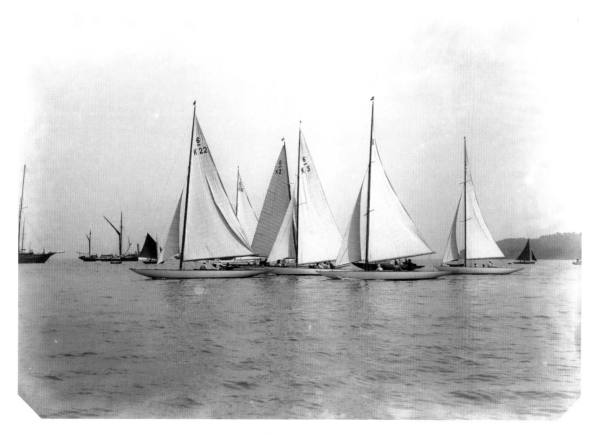

6-metre class, 1922

Ara, 1922

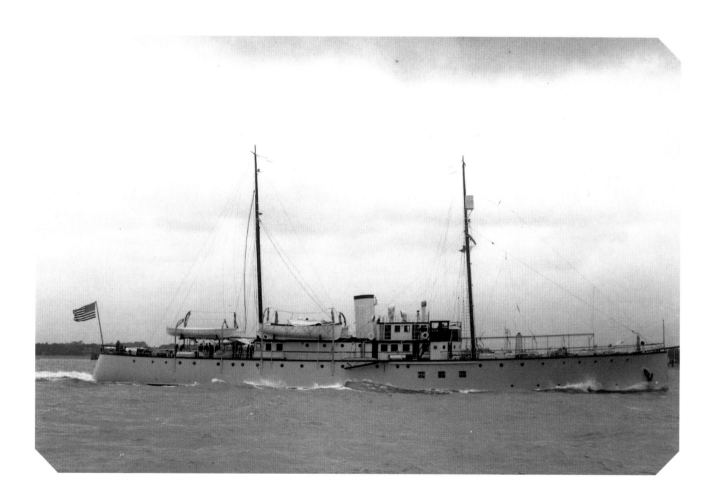

The King's Cup, 1928

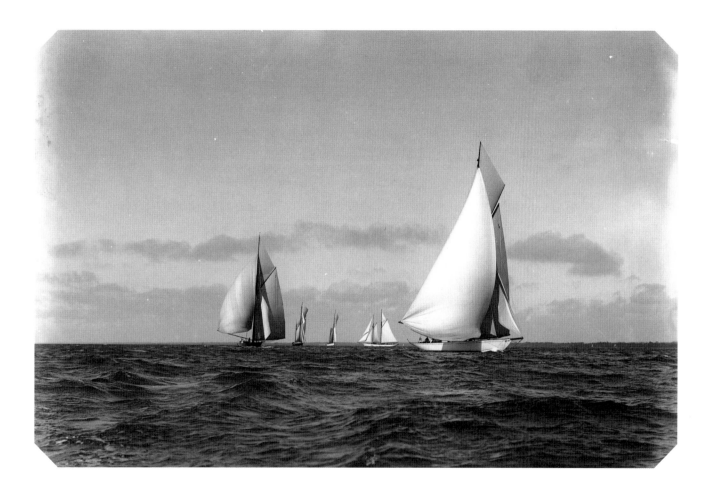

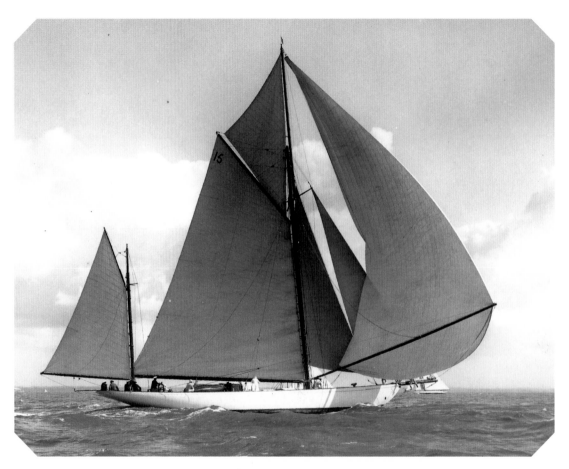

Suanuru, 1922

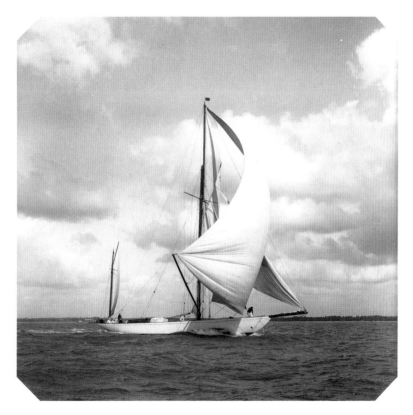

Suzanne, 1922

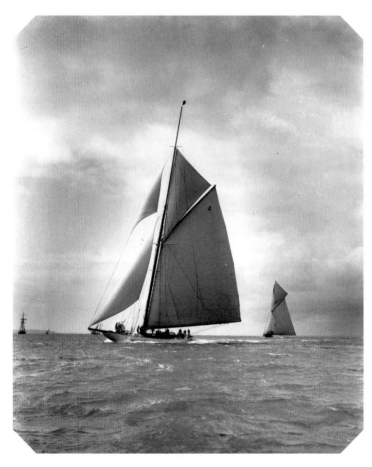

Nyria & Britannia, 1920

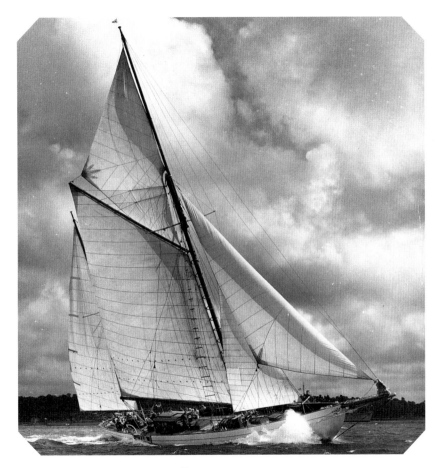

Cynara, 1927

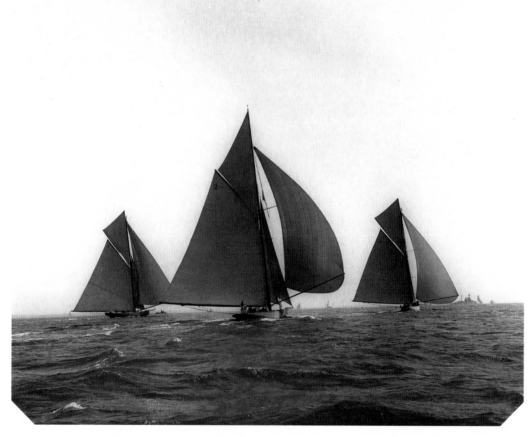

Terpsichore, Paula III & Moonbeam, 1928

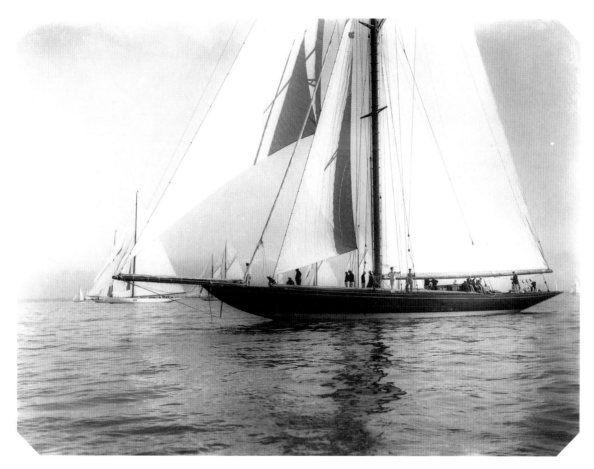

Shamrock, 1927

Westward & Britannia, 1927

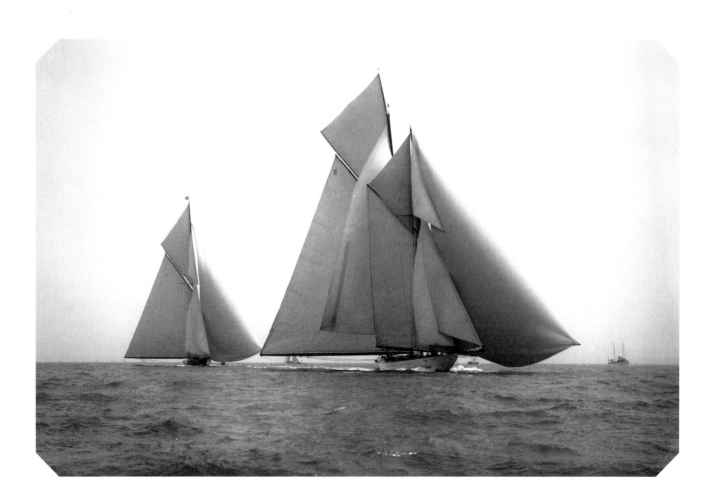

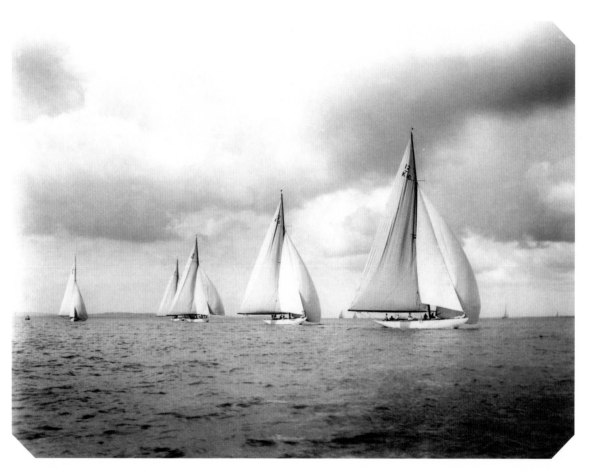

Moyana II leading the 12-metre class, 1920

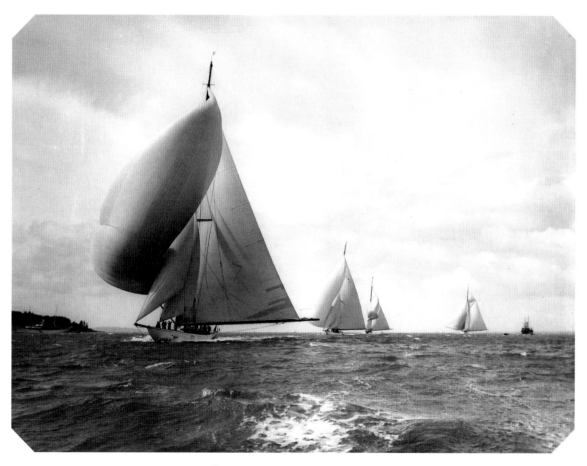

Candida leading, 1929

Deck of Britannia, 1921

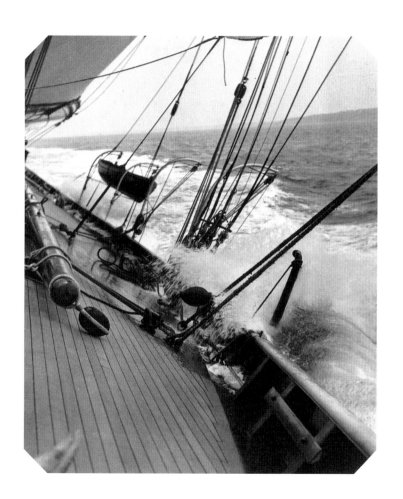

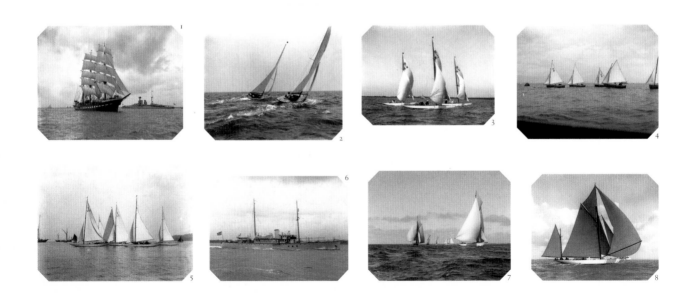

1 The stark contrast of Arthur Guinness' *Fantome II* and HMS *Warspite* underlines the gentler aspirations of many yachtsmen who took to the seas in the aftermath of the First World War. *Fantome II* was built as a French cargo ship in 1896 and subsequently fitted out with luxury cabins fit for a more rarefied cargo.

2 The Solent Sunbeam one-designs *Sally* and *Joy* were typical of the many small classes that were established to provide relatively economic yacht racing in the inter-war years.

3 The International Rule that gave rise to the metre classes lapsed during the First World War. Before the Yacht Racing Association had established its Second International Rule and a rival organisation, the Boat Racing Association, introduced a series of smaller classes such as the International 18-foot class.

4 Growing popularity against a background of spiralling costs was responsible for the widespread emergence of dinghy racing. The International 14-foot class was an early and long lived class.

5 In the early 1920s, fleets of grand schooners and outsized cutters were mere memories. Despite this, yachtsmen were determined to maintain the traditions of their sport; international yacht racing was reborn in the 6-metre class. The yachts were too small to make the passages to racing centres but they were shipped by rail and liner to new competitions throughout Europe and on both sides of the Atlantic.

6 The first large diesel powered motor yacht was launched just prior to the war. *Ara* was the second of the type to be built. A far cry from the elegant steam yachts they superseded, the new motor yachts introduced a modern aesthetic to powered yacht design.

7 By 1920, large yacht racing was beginning to find its feet but the eclectic fleet that gathered for the premier King's Cup of that year's Cowes Week amply demonstrates the decimation that British yachting had suffered. By the late 1920s, old memories and renewed ambitions led a revival of the big class.

8 The yawl *Sumurun* was designed by William Fife as a fast cruiser in 1914. The collapse of yachting in the aftermath of the First World War was so great that her owner, Lord Sackville, found himself in possession of one of the finest vessels that could be mustered to race against *Britannia* at Cowes.

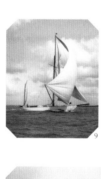

9

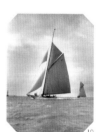

10

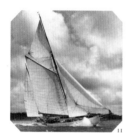

11

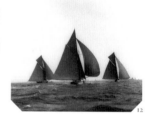

12

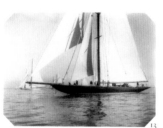

13

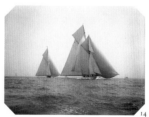

14

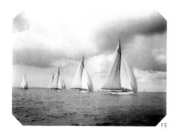

15

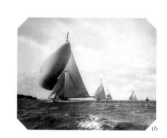

16

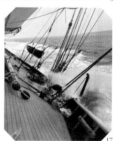

17

9 The practical advantages of the manageable rigs and more reasonable proportions of yachts like *Sumurun* were not enough to convince yachtsmen to give up the ambition of a new big class.

10 The rebirth of the big class was initially dependent on George V fitting out *Britannia* and a small number of enthusiasts modernising older yachts. Here the royal veteran is being led by *Nyria* of 1906 vintage.

11 In the inter-war period the construction of ocean-going cruising yachts like *Cynara* recovered far sooner than that of the extreme racing yachts.

12 With the 15-metre class disbanded, *Paula III* could only trail the large and disparate cutters *Terpsichore* and *Moonbeam*. Both of these first sailed in 1920 but neither was built to any particular rating rule which further compounded the difficulties of re-establishing big class racing.

13 Sir Thomas Lipton's 23-metre class *Shamrock* was fitted out in 1920 and made the passage to New York to help tune up his America's Cup challenger *Shamrock IV*. Once returned to British waters, she was another of the dissimilar yachts that made up the big class.

14 1927 was the last year of the makeshift big class but

the schooner *Westward* and the royal cutter *Britannia* who had done so much to help re-establish it remained an integral part of the class long after the appearance of a new generation of big class cutters.

15 The 15-metre class was not reinstated under the Second International Rule of 1920. In its place the 12-metre class was gradually adopted as the premier intermediate sized racing class. By the late 1920s, a fleet of 12-metres had been established on the Solent. Here *Moyana II* leads *Vanity*, *Modesty*, *Rhona* and *Noresca*.

16 In 1928 two new first class cutters were commissioned. In 1929 *Candida* was laun-

ched to lead a revitalised big class into its final and most successful decade.

17 Heeling to the breeze *Britannia*'s lee rail dips into the passing seas. In the 1930s her bulwarks were trimmed down in a bid to squeeze yet more speed out of the old cutter.

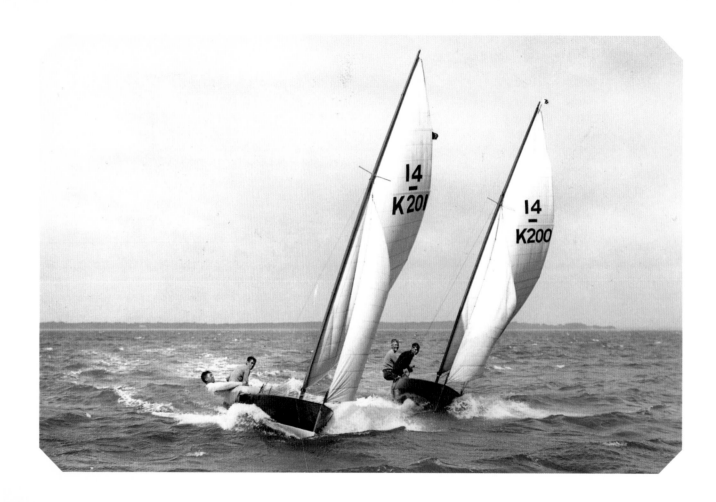

1930–1939

A FLAMBOYANT END

A FLAMBOYANT END

SIR THOMAS LIPTON'S FINAL ATTEMPT TO WIN THE
America's Cup in 1930 brought an end to a long-established
school of gentlemanly yacht ownership. In the 1930s, a new
generation of yacht owners emerged who no longer relied on
professional skippers but steered their own yachts. The impact
of the new hands-on yachtsmen was furthered by changes in
the rating rules, bringing a close to the relative hermetism that
surrounded the America's Cup and prompting the greatest years
in history of the big class.

In a complex negotiation American yachtsmen agreed to adopt
the Second International Rule for all yachts up to 12-metre size
and the British accepted the American Universal Rule for larger
yachts. Thus, the J-class yachts, as the big class yachts built to

the Universal Rule were known, came to form the back bone of the revitalised British big class. Now, with one yacht it became possible to race in home waters and attempt to win the most prestigious trophy in yachting. Remarkably the adoption of the American rule for the big class did not prompt the demise of the older members of the class. With slight modifications several of the existing yachts were able to race under it. Even the King's *Britannia*, a veteran of the 1893 season, was converted to the more modern Bermudian rig and remained competitive.

The "Flying Millionaires" Sir Thomas Sopwith and Sir Richard Fairey typified the modern approach. They had begun their careers in smaller yachts, competed in the 12-metre class, graduated to the big class and always took the helm. In the quest

for speed, they used their own scientific skills to introduce new technology to yacht racing, becoming amateur experts at the leading edge of their sport.

Soon after Lipton's death Sopwith resolved to challenge for the America's Cup and bought *Shamrock V* to practise on. Woolworth's British chairman W. L. Stephenson built a new J-class in 1933 and after she proved successful Sopwith turned to the same designer, Charles E. Nicholson, for his first *Endeavour*. The 1934 America's Cup broke the hearts of British sailors, *Endeavour*, clearly the faster boat, snatched defeat from the jaws of victory. To this day the 1934 contest remains the closest Britain has ever come to winning the elusive trophy. The American J-class *Yankee* visited British waters in 1935 and the

overall success of the season encouraged Sopwith to challenge again. Allowing a year for tuning up, *Endeavour II* was launched in 1936 but the death of George V that year and the subsequent scuppering of *Britannia* led to the demise of the big class. In 1937, *Endeavour II* was thoroughly outclassed in what was to be the last outing for the J-class.

Freed from the overwhelming dominance of the big class, the 12-metre class prospered, achieving a far more numerous and well-balanced class than had ever been possible when the big cutters were still sailing. Had war not intervened they might even have gone on to rival the 8-metre class which, released from the constraints of extremes, had enjoyed amongst the best sport to be had in class racing throughout the period.

Shamrock V, 1930

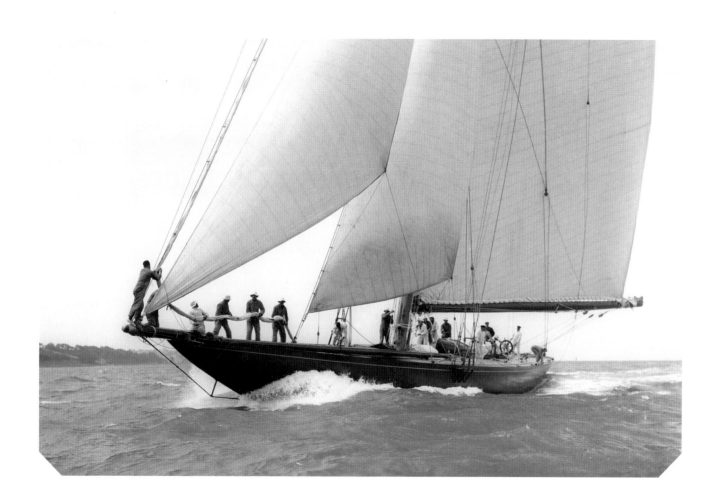

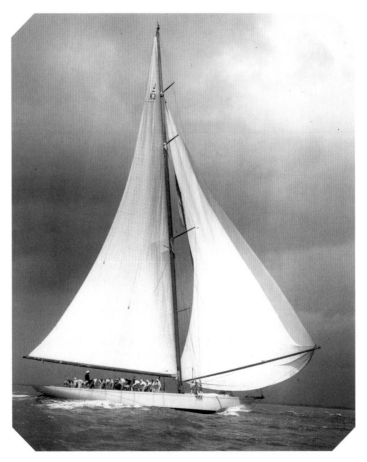

Shamrock V, 1934

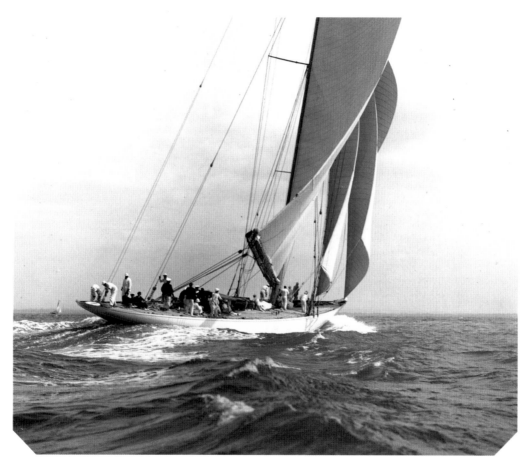

Velsheda, 1934

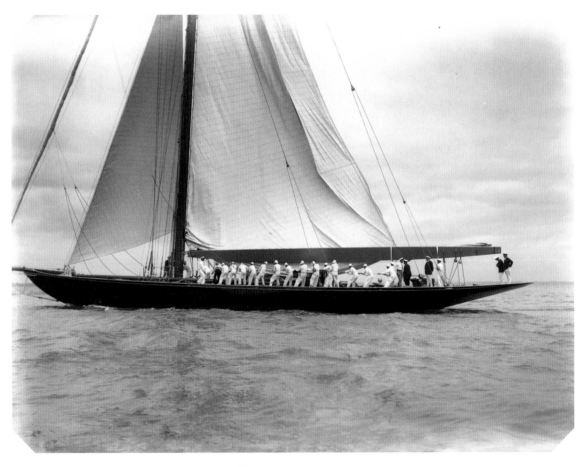

Britannia, 1930

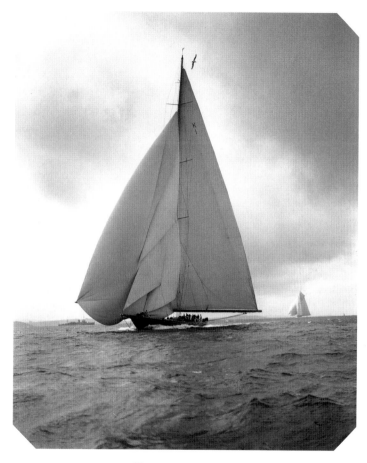

Britannia, 1931

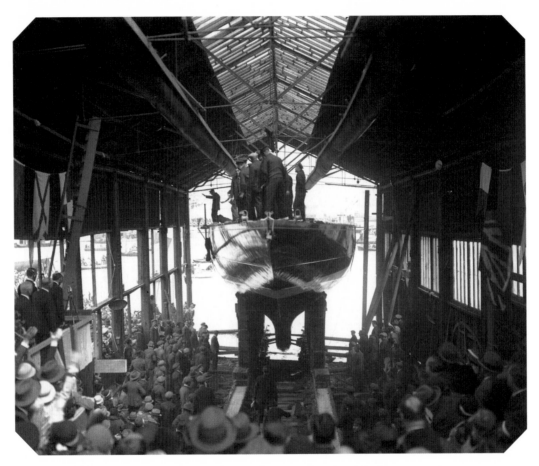

Launch of Endeavour, 1934

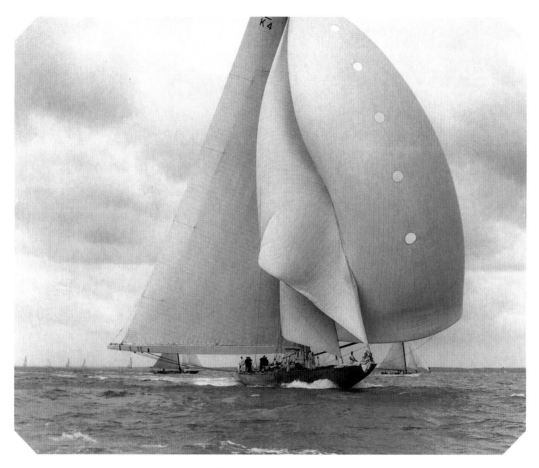

Endeavour, 1936

Astra leading the J-class, 1985

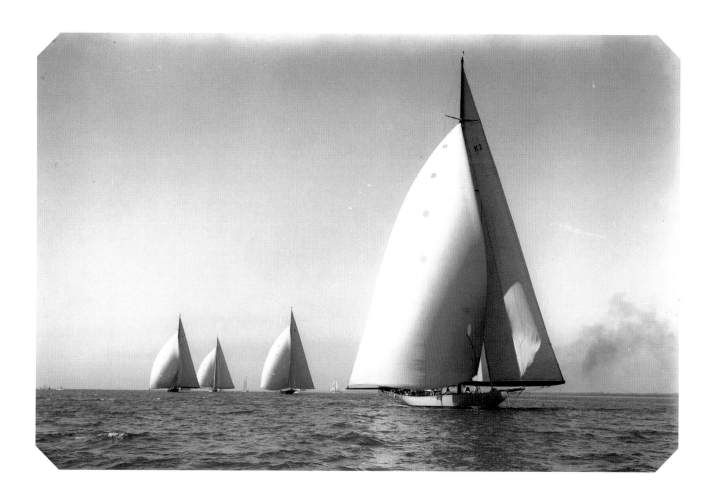

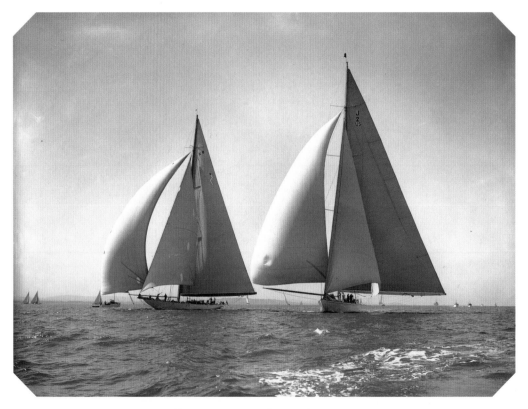

Candida & Yankee, 1935

Malahne, 1937

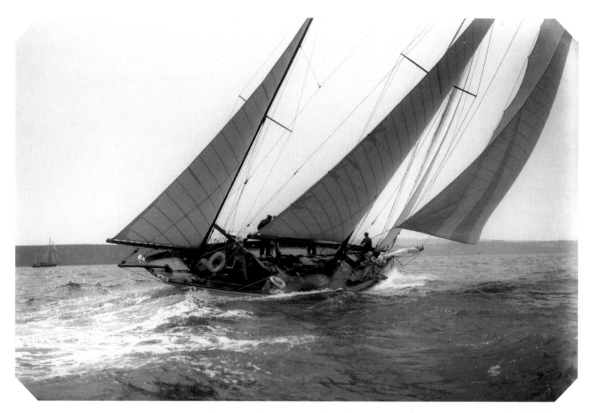

Aralus, 1937

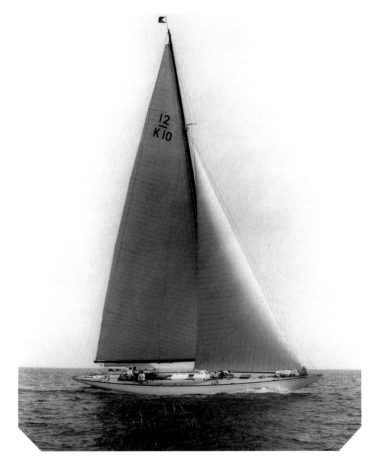

Trivia, 1937

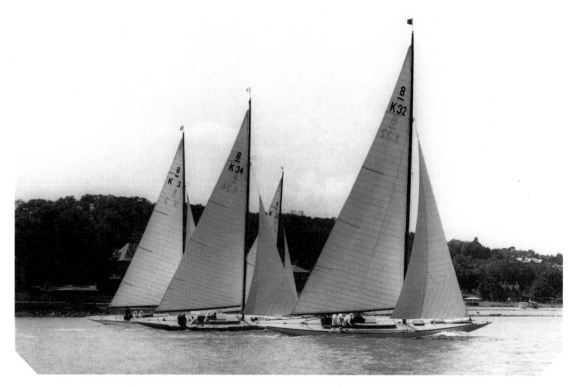

Wye leading Rosa, Felma & Saskia, 1938

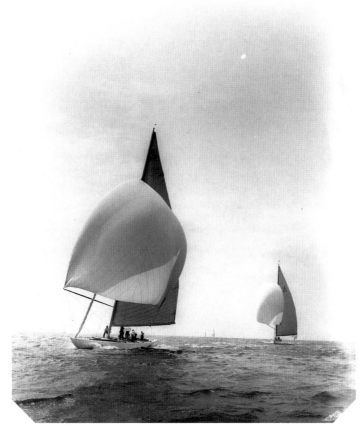

Tomahawk, 1939

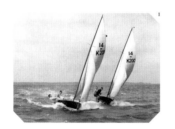

1

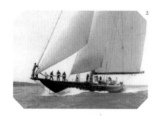

2

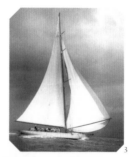

3

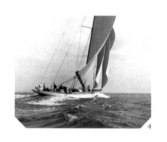

4

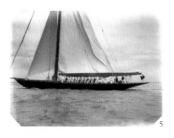

5

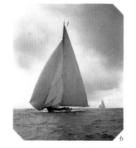

6

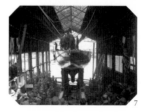

7

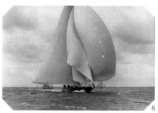

8

1 The combination of ever-increasing popularity of yachting, rising costs and an increasingly hands-on approach helped several dinghy classes to flourish in the 1930s. The International 14s were one of the most competitive.

2 Following defeat in the 1930 America's Cup, *Shamrock V* was acquired by Sir Thomas Sopwith who used her as a trial horse for the various technical innovations introduced on *Endeavour*. She was subsequently acquired by Sir Richard Fairey who continued to race her in the big class.

3 With mast towering 160 feet above the water and setting acres of sails, many of the individual tasks involved in racing manoeuvres of the J-class required the combined strength of all their crew. Here the crew of *Shamrock V* are hauling in the mainsail prior to jibing.

4 The second British J-class yacht was commissioned by Woolworth's chairman W. L. Stephenson. He had previously owned the 1907 23-metre class *White Heather II* but scrapped her in 1932 to build *Velsheda*.

5 Raising the enormous mainsails of the big class yachts was the first in a series of heavy tasks undertaken by the crew on every racing day. As with all the big class yachts *Britannia's* crew were mostly fishermen who returned to their trawlers at the end of the yachting season.

6 In 1931, *Britannia* was modernised so that she could race with the new J-class yachts. Her enormous new Bermudian rig was designed by Charles E. Nicholson and it was largely responsible for her continuing success in her fourth decade.

7 Like all the British J-class, *Endeavour* was designed by Charles E. Nicholson. Launched in early 1934 amongst a deluge of popular enthusiasm she was considered by many to be the most beautiful of the class.

8 *Endeavour's* speed was outstanding, she dominated racing in British waters until setting off on her challenge for the America's Cup which she lost only through poor tactics. Even her American rivals considered that she was faster than their defender.

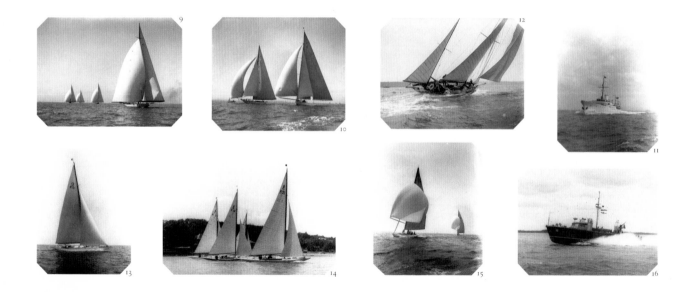

9 Of the 23-metre class yachts built in the late 1920s, *Astra* converted particularly well to the J-class rule and in light airs there was little her younger and larger sisters could do to beat her.

10 After the disappointment of the 1934 America's Cup, the visit of the American J-class *Yankee* in 1935 encouraged Sir Thomas Sopwith to challenge again. Seen here with *Candida*, *Yankee*'s presence in British waters prompted one of the most successful seasons on record.

11 The J-class cutters all had comfortable accommodation but few of their owners ever used it since they invariably also owned palatial motor yachts. To escort *Velsheda*, W. F. Stephenson had Charles E. Nicholson design him *Malahne*. In turn she passed into the ownership of film mogul Sam Spiegle.

12 In contrast to the majestic big class cutters, the yawl *Aralus* is typical of a type of yacht developed for ocean racing. Initiated in America this new form of yacht racing was first taken up in Europe in the 1920s with the organisation of classic races such as the Fastnet.

13 When big class racing collapsed with the death of George V and the scuttling of *Britannia* in 1936, all the keen owners reverted to the 12-metre class. In the final years preceding the Second World War, the class grew year on year. *Trivia* was one of four yachts designed by Charles E. Nicholson for the 1937 season.

14 The quality and closeness of the racing in the 8-metre class attracted many owners to it during the 1930s. Typically, the racing was close. Here *Wye* seems to have a slight advantage on *Rosa*, *Felma* and *Saskia*.

15 In the final pre-war season Sir Thomas Sopwith's American rival in the J-class, Harold S. Vanderbilt, brought his 12-metre *Vim* to race in British waters. It was a salutary experience for Sopwith whose *Tomahawk* could do little against the outstandingly fast visitor.

16 The outbreak of the Second World War put yachting and yachting photography into abeyance. Remaining on the water Keith Beken served aboard the air-sea rescue launch *ASR 198*.

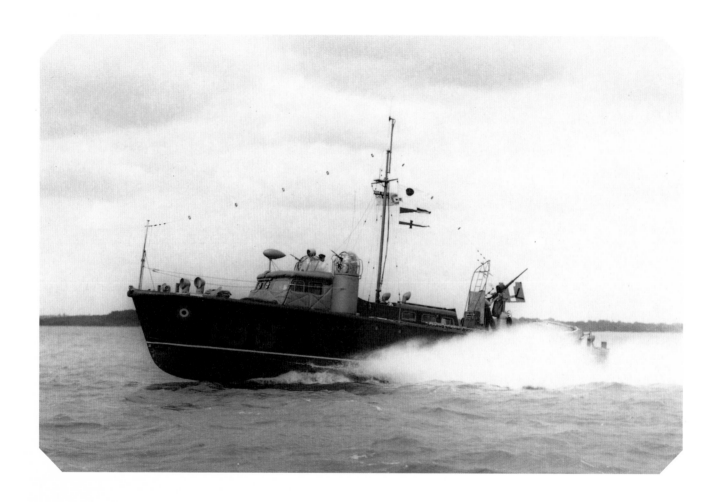

Published in 1999 in Great Britain as *The Beken Album*
by The Harvill Press, London.

Library of Congress Cataloging-in Publication data is available.

ISBN 0-812-93283-8

Random House website address: www.atrandom.com

2 4 6 8 9 7 5 3

First US Edition

Designed by Rachida Zerroudi
Originated, printed and bound in Italy by Arti Grafiche Amilcare Pizzi

SPECIAL SALES
Times Books are available at special discounts for bulk purchases
for sales promotions or premiums. Special editions, including personalized covers,
excerpts of existing books, and corporate imprints, can be created in
large quantities for special needs. For more information, write to Special Markets,
Times Books, 201 East 50th Street, New York, New York 10022, or call 800-800-3246.